Fashion & Anti-fashion

Fashion & Anti-fashion

exploring adornment and dress from an anthropological perspective

Ted Polhemus

A classic text from 1978 revised with a new introduction and postscript for the 21st century

Originally published as the introductory text of *Fashion & Anti-fashion: An Anthropology of Clothing and Adornment* by Ted Polhemus & Lynn Procter, Thames & Hudson, London, 1978 (Nikos Stangos, editor).

This book was typeset and produced using Open Source software. LyX was used for typesetting and layout. My sincere thanks to all who work in Open Source. Special thanks also to Alan L Tyree whose *Self-publishing with LyX* got even me from a to b.

ISBN 978-1-4477-3936-4

For Charlotte Polhemus, Fanny LeFèvre and Ken Kensinger

With thanks to Lynn Procter, Emilia Telese, Belén Asad, Philippa Morrow, Steve Dawson, Phil White, Kaustav SenGupta, Mick Mercer, Jamie Camplin, Alistair Gentry, Andrew White, Georgina Howell, The Society of Authors and the good people at LγX.

Front Cover *left:* Central Saint Martin's College of Art and Design, London, student fashion show, early 80s. Photo: Ted Polhemus.
right: tattooing on a native of Rapa Nui, Easter Islands (after K. Routledge) from Adolfo Dembo & J. Imbelloni, *Deformaciones Intencionales del Cuerpo Humano de Carácter Étnico* (Humanior, Biblioteca del Americanista Moderno (José Anesil), Buenos Aires, 1938).

Back Cover *left:* Kikuyu girl (Kenya) with ear ornaments *from Adolfo Dembo & J. Imbelloni,* Deformaciones Intencionales del Cuerpo Humano de Carácter Étnico *(Humanior, Biblioteca del Americanista Moderno (José Anesil), Buenos Aires, 1938).*
right: the author, photo by James Lange, PYMCA.

Contents

Part I

Introduction to the 2011 Edition

What is fashion? What is style? What, if anything, is the relationship between them? What sort of society generates one or the other?

These are some of the key questions which I've been trying to chip away at for more then 35 years. My first published attempt was *Fashion & Anti-fashion* which appeared (from Thames & Hudson, London) in 1978. I had begun writing it while a graduate student at University College, London under the tutelage of Professor Mary Douglas. Although revered (and rightly so) for books such as *Purity and Danger* and *Natural Symbols* which boldly applied anthropological thinking to the human body – its beauty, health, symbolic resonances, right down to its cleanliness and waste products – even Professor Douglas was clearly disappointed whenever I

raised the subject of fashion or the bubbling subcultural streetstyle caldron of London in the 70s which had just seen Glam come and go and could just about make out the harrowing shape of Punk on the horizon.

For the vast majority of anthropologists at that time anything to do with body decoration, adornment, streetstyle, visual communication – and most certainly fashion – was simply not a subject to be taken seriously. Perhaps this bias stems from the early days when anthropologists and explorers before them shocked the world with tales, drawings and then photos of Amazonian natives with lip plugs the size of CDs or the gorier details of African scarification – the days when, at least in the popular imagination, anthropology seemed to be about little other than mind-boggling 'deformations' of the body.

Or perhaps it was simply the inability of anthropology to burst the boundaries of its roots in the West where, historically, the word has long been seen as more civilized and sophisticated than the image; where the body is a mere housing for the all important soul; where 'I am' because I think; where science fiction and even some actual scientists yearn for the day when a naked brain can happily bubble away in a vat of chemicals without the encumbrance of a body. Whatever the reason, in the years ahead, as I found work opportunities which allowed me to further my investigations into fashion, body decoration, streetstyle, etc., I steadily

exiled myself from academic anthropology. (Which is ironic when you consider how many anthropology students today are writing a thesis on subjects like Japanese streetstyle, body piercing or representations of the body in computer games. The hazards of being ahead of one's time, etc.)

This presumption on the part of an older generation of anthropologists that the body and its adornment, modification and clothing is somehow a frivolous, tangential, insignificant subject has always pissed me off. Recent excavations at the Blombos Cave in South Africa have found pieces of bright orange/red ochre which it is thought were used for body painting and shell necklaces which are between 70,000 and 100,000 years old.[1] As well as doubling or tripling the starting point of 'modern human behaviour' (and placing it in Africa rather than Europe), these Blombos finds are so exciting because they demonstrate once and for all that the deliberate transformation and decoration of the body has always been a cornerstone of what it means to be human – to be the one and only decorated ape.

Ironically, over the years since *Fashion & Anti-fashion* was written, operating more often than not from (sort of) within the fashion industry, what pisses me off is exactly the same thing as I found long ago amongst academic anthropologists: a disinclination to take fash-

[1] See http://www.svf.uib.no/sfu/blombos/Artefact_Review2.html and http://cogweb.ucla.edu/ep/Blombos.html

ion seriously. In particular, a disinclination to think seriously about what fashion is, what it isn't and what its structure and functions are.

When *Fashion & Anti-fashion* was first written in the late 70s we had already seen profound changes in the fashion system – changes not only between this 'look' or that 'look' but, more significantly, internally, within the mechanisms, the guts, the processes, the functions and the objectives of the 'fashion industry'. Yet, how rarely, even now, are these changes explicitly acknowledged as fashion journalists, marketing gurus and 'cool hunters' (god help us) frantically search out that singular, consistent 'direction' – that 'Next Big Thing' – which the fashion system of old delivered like clockwork but which our delightfully chaotic, diversified, independent creative consumer post-modern world seems incapable or unwilling to conform to. The writing is not only on the wall but it is, moreover, writ large and most exciting: there will never ever again be a single Next Big Thing. The elephant is in the room and crapping all over the old models, mechanisms and functions of that kind of fashion which once ruled the world but has now apparently gone out of fashion. A revolution has taken place but most prefer to act like it's still 1947, Dior's 'New Look' has just been unveiled and all the world's customers have meekly fallen into line and are patiently waiting for it to 'tickle down' to a shop they can afford. Not.

And this toppling of fashion's capacity to dictate a

singular 'direction' is only part of its structural makeover. In the same year that Dior so successfully launched his 'New Look' – 1947 – there were Bikers in California who would become the model for *The Wild One*, goateed Hipster beboppers in smoky jazz clubs in NYC and Jack Kerouac and Neal Cassady somewhere in between, *On the Road*, modeling a new denim workwear/ sports casual style which, in time, would become the world's favorite. Was Monsieur Dior worried by this stylish competition? Not on your nellie: for fashion was still fashion and what went on on the 'street', on 'the wrong side of the tracks' and amongst the plebs was most certainly of no interest to a fashion industry which knew full well that it alone (and Paris alone) had the monopoly on taste and style. Yet, as we now know, this too would change – and do so with breathtaking speed and global impact.

Despite even the extraterrestrial, mind-boggling possibilities which the Punks brought to the streets of London in 1976 (and which I was fortunate enough to view at close hand), it never occurred to anyone, including myself, that within a decade or two it would become impossible to delineate where fashion ended and anti-fashion (what I would now call *style*) began. And that moment came only a few years later in the 80s when suddenly to describe someone as 'trendy' went from a compliment to a put-down and when suddenly the greatest sin was to be a pathetic 'fashion victim'. When, for the first time, lots of different designers with lots

of different styles in lots of different countries carried on side by side and when, instead of here-today-gone-tomorrow throw away fashion, more and more people opted for 'timeless classics' – be it a little black cocktail dress, a Schott Bros 'Perfecto' black leather motorcycle jacket or a tattoo.

Yet to an extraordinary extent the fashion industry carried on (and still carries on to this day) as if none of this has happened – as if the fashion industry was still successfully dictating a single 'New Look' which one and all would passively, sheep-like adopt in due course; as if consumers would always hunger for in-stant novelty and always shun classic style; as if every-one still accepted that only fashion professionals know how to 'coordinate' to achieve an aesthetically accept-able, designer approved 'total look'. Except that they didn't and they don't and we now reside in what I have elsewhere[2] termed 'The Supermarket of Style' – a post-modern world where anything goes and new style inspi-rations get sampled & mixed by a new breed of creative consumers who do their own thing and a fashion indus-try where diversity refuses to be squeezed into a single 'direction' even in the pages of *Vogue* let alone on the street.

In this sense everything I wrote in *Fashion & Anti-fashion* is completely out of date. Arguably, the true fashion and the true anti-fashion costume/streetstyle as

[2]See the final chapters of *Streetstyle* (London, 2010).

identified in this late 70s text simply no longer exist in the 21st century. As apparently happens when matter and anti-matter come into contact with each other, when, from the late 70s onwards, fashion and style began getting off with each other, both simply annihilated each other. But even if this is the case, it seems helpful to return to that last moment when fashion and style each had distinctive structures, identities, functions and constituencies – if only to appreciate just how extraordinary it is that in only a few decades these two distinctive, long established approaches to decorating, modifying and clothing the human body should have produced such a strange mutant offspring. What is clear in 2011 is that nothing is clear. Perhaps, just perhaps, by tracking back to a time when fashion was fashion and style was style we can make a little more sense of our delightfully confusing post-modern situation.

Or, perhaps, alternatively, by tracking back to the late 70s we can appreciate that it isn't fashion and style which have changed but rather their geography. Paris may still be the foremost centre of fashion but consider how few of its catwalk shows now display the work of French designers. And will the Internet now make possible a truly global age when new designers, new looks and new inspirations bubble up from anywhere and everywhere? Perhaps even, in time, bypassing the prohibitively expensive, 'gatekeeper' controlled ritual of catwalk shows within a specified 'Fashion Week' and rig-

orously defined 'season'?

Additionally, while America and Britain bred decades of in-your-face subcultural streetstyle – mindboggling streetstyle which swept around the world – now it is Japan, Eastern Europe and South America (and who knows where tomorrow) which point the way forward for anti-fashion. And to flip the fashion/anti-fashion coin over: while I may or may not be right that the 'West' (whatever that means nowadays) is post-fashion, we can see that precisely that socio-economic mobility and modernist, ever optimistic, things-can-only-get-better-worldview which I identify in *Fashion & Anti-fashion* as the breeding ground of ever-changing, 'new look', 'directional' fashion is present in China, India, Brazil and elsewhere in the 'emerging world' today. So, as I say, it may be that fashion is still fashion and style is still style – but just not here in the soon to be past its sell by date 'West'.

When *Fashion & Anti-fashion* first appeared in 1978, published by Thames & Hudson, it was subtitled '*an anthropology of clothing and adornment*', co-authored with Lynn Procter and most of its pages were taken up with pictures organized around specific themes such as 'Adornment as personal expression', 'The permanent body arts', 'Fashion as change' and 'Anti-fashion as utopia'. The text which is reproduced here constituted an unillustrated introductory section (which, unlike the rest of the book which was highly dependent on

her contribution, had little direct input from Lynn Procter – who has kindly given permission for this introductory text to appear here under only my own name). In going over this text in preparation for this book I couldn't help myself from reorganizing, revising and in a few instances rewriting bits of the original text in the interests of clarity. But, like any responsible time traveller, I have held myself back from correcting or altering that which can only be known with the benefit of 30+ years of hindsight – including the final paragraph ending which blatantly and embarrassingly fails to predict the future which was just around the corner.

Soon after its publication, *Fashion & Anti-fashion* was reviewed by Angela Carter in the (now, like Angela, sadly departed) *New Society* magazine. (Yes, that Angela Carter but before she became known as a writer of wondrous fiction.) She begins:

There's a 'compare and contrast' pair of photographs in this delicious book. One is of real Ozark hillbillies, mostly barefoot, in ragged, faded yet touchingly well laundered workclothes, the garb of decent, hard working poverty. The other is of fake or cosmeticised or 'fashionalised' hillbillies, models demonstrating the 'Hillbilly Look' of circa 1975, crisp, print skirts and natty overalls, the fashion industry's tribute to the Simple Life, the garb of chic down-dressing.[3]

Yes, dear reader, a 'delicious book'! Thirty-five plus years of writing later I can't recall a nicer, more wel-

[3]Carter, Angela, 'Dressing up and down' in *New Society*, 30 November 1978, p. 529.

come comment from a critic (and this from a writer who, as well as her subsequent accomplishments in fiction, was herself a formidable pioneer in the discovery of just how much can be gleaned about our world in the deepest sense from the seemingly frivolous sheen of popular culture).[4] And she also provides a succinct summary of Lynn Procter's and my intent: 'This is the main thesis of the book; sartorial style and its relation to social function is what *Fashion and Anti-Fashion* is about'.[5]

And, as if Angela Carter could look into the future to see this present, 21st century moment when I would republish the introductory text of *Fashion & Anti-fashion*, she advises 'It would be a pity if the pages of introductory text were skipped; they present a most cogent argument for the seriousness of the study of fashion . . .'[6] But she goes on '. . . even if, after a brisk semiological run around, the authors finally settle for a definition of fashion as "a grand illusion". Which, after raising so many questions in the reader's mind, is a bit like saying: "Well, you can wake up, now; it was all a dream, really".'[7] And, in retrospect, I have to admit that she was as right in her criticism as her complements – the

[4]See *Arts in Society* edited by Paul Barker (Five Leagues Publications, Nottingham) which, as well as Angela Carter's delicious essays on male pin ups and make-up, includes notable contributions from John Berger, Dennis Potter, Michael Wood and Paul Barker (once the pioneering editor of *New Society* magazine).

[5]Carter, Angela, *Ibid*.

[6]Carter, Angela, *Ibid*.

[7]Carter, Angela, *Ibid*.

text ending in a fluffy pastry signifying nothing much at all. And even getting that wrong. For by suggesting in the final sentence that the fashion system would forever be 'to be continued' I completely failed to consider the possibility that that great glistening, gleaming machine of perpetual motion and 'direction' was about to splutter and hiss and clank to a halt. Or, at the very least, to evolve into a very different beast indeed (as will be considered in the postscript to this edition).

Ted Polhemus

Hastings, April 2011

Part II

Fashion & Anti-fashion

Chapter 1

The Decorated Ape

Although anthropology is traditionally defined as 'the study of man', throughout most of its history it was generally presumed that the study of some men is more appropriate than the study of others: the assumption being that it is more useful to study so-called 'primitive' people than 'civilized' people, more appropriate to study non-Western than Western peoples and better to study men (especially 'Big Men' such as chiefs) than women. As fashion is usually presumed to be a female preoccupation occurring only in the 'civilized' West, the study of fashion is usually omitted from the study of man. Anthropology has, however, produced many studies of body decoration, 'deformation', clothing and adornment.

In contemporary Western society the term 'fashion' is often used as a synonym of the terms 'adornment', 'style' and 'dress'. My aim here is to fine-tune *fashion*

as a unique and specialized form of body adornment, dress and style. The term 'adornment' will be used as a generic label for all of the things people do to or put on to their bodies in order to make the human form, in their eyes, more attractive or meaningful. In chapter 2 this generic subject will be subdivided into two distinct types, fashion and anti-fashion, but first it will be useful to see how anthropologists have investigated the broader subjects of bodily adornment and clothing.

Even before anthropology developed as a branch of the social sciences, explorers such as Captain Cook reported on the bizarre and drastic things which people throughout the world did to their bodies for the sake of decoration. When anthropologists started looking at corporal adornment in the more remote corners of the world, their accounts were usually simple descriptive studies of the materials of adornment, for example the number, type and colour of feathers in Brazilian headdresses. There were, however, in time, some students of adornment who attempted to move beyond simple description and to explain, within the context of some theoretical framework, the reasons *why* people clothe and adorn themselves.

One of the oldest and most common approach to the rationale of clothing and adornment suggested by anthropology concerns their functions. Functionalism, as developed by Bronislaw Malinowski, predisposes us to accept that human beings 'function' as they do to sat-

isfy a limited range of 'basic needs' which are presumed to generate various 'cultural responses':

Basic needs » Cultural responses

1 metabolism » commissariat

2 reproduction » kinship

3 bodily comfort » shelter

4 safety » protection

5 movement » activities

6 growth » training

7 health » hygiene[1]

Thus, for example, the need for bodily comforts, according to Malinowski, prompts people throughout the world to create various forms of shelter, from igloos and castles to the more portable forms of shelter known as clothing, with automobiles and the like somewhere in-between.

The way in which clothing, like architecture, is seen by the functionalist as a response to purely practical requirements for shelter to sustain bodily comfort (e.g. against cold weather, briars or sunstroke) excludes the 'frivolous fashions' which chic Westerners wear with little or no regard for the elements. Indeed, the typical primitive tribesman or tribeswoman is just as seemingly impractical when it comes to his or her clothing and adornment. For example, adolescent youths of the Nuba tribe of the Sudan

[1] Malinowski, Bronislaw, *A Scientific Theory of Culture and other Essays*, Oxford University Press, 1960, p. 91.

. . . will usually have a new [body painting] design each day, a design which may take them up to an hour to accomplish. If girls from other villages are visiting, or if an important dance is pending, they may decorate and design twice in the same day. These young men will avoid brushing against people or things (and certainly avoid wrestling – the sport characterising their age grade) if they have just finished an elaborate design, and sleep only in a single position to minimise the body surface on the sleeping rack. In order to protect the elaborate hair decor ... they must sleep with their necks on the edge of the sleeping rack – their heads suspended the entire time.[2]

And women of the Kalahari Bush have been known to continue their practice of beautifying themselves by smearing animal fats on their bodies to make them shiny even when animal food supplies are at a premium for nutritional purposes. In fact, it takes little more than a quick look through any issue of *National Geographic* to appreciate that people all over the world, primitive and civilized, male and female, rich and poor, devote a great deal of time and valuable resources to clothing and adorning themselves in ways which provide little or no shelter from the elements. Why?

We know that not everyone in the world finds it necessary to wear clothes. Nudists group together in colo-

[2]Faris, James, *Nuba Personal Art*, Duckworth, London, 1972, pp. 62-4.

nies from California to Russia. We also know that there are, in some parts of the world, 'naked savages', although, sadly, it is likely that there are now more of these in Saint-Tropez than in the rest of the world put together. What is important is that climate does not always determine whether or not clothes are worn, as Charles Darwin learned on his visit to Tierra del Fuego: despite the Antarctic climate, the primitive tribesmen saw no need to protect themselves from the elements. As Flügel comments in *The Psychology of Clothes*:

Darwin's often-quoted observation of the snow melting on the skins of these hardy savages, seems to have brought home to a somewhat startled nineteenth-century generation that their own snug garments, however cosy and desirable they might appear, were not inexorably required by the necessities of the human constitution.[3]

Indeed, when these same tribesmen were later introduced to snug, cosy European clothing it had a debilitating effect upon their health and (no doubt in conjunction with the onslaught of Western diseases) was perhaps a significant factor in the decline of their population.

Some have suggested that adornment and the sort of clothing which is unnecessary for protection from the elements fulfills a human need for modesty, but clearly there is 'no essential connection between clothing and

[3]Flügel, J. C., *The Psychology of Clothes*, Hogarth Press, London, 1930, p. 17.

modesty, since every society has its own conception of modest dress and behaviour'.[4] Thus, when the Finnish explorer Baron von Nordenskiöld on one of his travels up the Amazon attempted to purchase the nose and lip plugs of a 'naked' Botocudo woman, 'only irresistible offers of trade goods at long last tempted her to remove and hand over her labrets. When thus stripped of her proper raiment, she fled in shame and confusion into the jungle.'[5]

Likewise, a Masai woman whose genitals are covered only by an absurdly brief leather skirt which in truth more closely resembles a belt 'would be overcome with shame if anyone, even her husband, should see her without the special brass earrings which she wears to signify her married status'.[6] And, 'as late as 1936, old-timers among Comanche males felt acutely uncomfortable and indecent if they thoughtlessly went out without a g-string, even though fully clothed in American store pants and shirt'.[7]

The extreme cross-cultural variability of the expressions of modesty in dress makes it 'perfectly clear that the use of clothing does not rise out of any innate sense

[4]Brown, Ina Corinne, 'What shall we wear?' in Roach, Mary Ellen, and Joanne Bubolz Eicher (eds.), *Dress, Adornment, and the Social Order*, John Wiley & Sons, New York, 1965, p. 10.

[5]Hoebel, E. Adamson, 'Clothing and ornament' in *Roach and Eicher*, p. 17.

[6]Anonymous, 'Costume for decoration' in *Family of Man*, part 34, p. 950.

[7]Hoebel, in *Roach and Eicher*, p. 16.

of modesty, but that modesty results from customary habits of clothing or ornamentation of the body and its parts'.[8] Surely it would be ridiculous to argue that there is a universal human need for the modest concealment of particular parts of the body as it preposterously proposes that those who do not cover these parts are not human.

The opposite theory of the function of clothing and adornment has also been put forth: that clothes fulfill our need for immodesty and exhibitionistic display in that they accentuate erogenous zones. There is something in this, as every stripper knows, but it is hardly a full explanation, as much adornment merely decorates what is already covered, and a great deal of clothing is deliberately unerotic. A fuller explanation is provided by those who suggest that adornment permits individualistic, personal expression. This is true of a lot of adornment: some military insignia differentiate one soldier from another, unique styles of dress may spotlight individuality and expensive fabrics, jewellery or upmarket brand logos can serve to advertise personal wealth. But the personal, psychological functions of dress and adornment are clearly only half the story.

Just as adornment allows us to assert ourselves as individuals, it also allows us to identify ourselves as part of a social collective. One asserts one's social, cultural, political, economic and geographic affiliations

[8] *Ibid.*, p. 17.

with buttons that say 'Win with Labour', rosettes with blazing team colours, hats labelled 'Kiss me I'm Puerto Rican', 'Hells Angels' tattoos and those forms of military insignia which express communality rather than individual distinction (e.g. branch of service insignia). In these and more subtle ways, dress and adornment may communicate 'I'm one of us'. Given that the tribe (arguably humankind's most important invention) was clearly a crucial component in our ancestors' unprecedented success as a species, the role of dress and adornment as a marker and symbol of tribal identity – 'I'm one of us' – has clearly been anything but frivolous and insignificant in human development.

As Mary Ellen Roach and Joanne Bubolz Eicher summarize in their essay 'Origins and functions of dress and adornment', the expressive functions of adornment and clothing are basically twofold: first, to 'express individuality by stressing unique physical features or by using unique aesthetics', and second, to 'express group affiliation or the values and standards of the group'.[9] It should be pointed out, however, that the so-called 'psychological' side of the equation has itself a social dimension: the individualistic is only that which deviates from the socially accepted norms prescribing what is unique and what is not.

While clothing and adornment have many functions,

[9]Roach, Mary Ellen, and Joanne Bubolz Eicher, 'Origins and functions of dress and adornment' in *Roach and Eicher*, p. 6.

these more often than not exceed the somewhat limited and practical functions of human activity which Malinowski originally identified. In particular, it is important to note that he neglected our basic needs for communication, expression and identification. In fact, the universality of adornment suggests that it is itself a basic need – one so fundamental that many of the needs which Malinowski presumed to be so important (bodily comfort, movement, health, etc.) are ignored for its sake. The painful practices of scarification, tattooing, ear, lip and nose piercing, tooth filing, cranial deformation etc. so frequently found in primitive tribes are obvious examples of this point. But equally, in Western society, the desire to 'look nice' and 'express ourselves' has us hobbling around on shoes which are uncomfortable and impractical, if not positively dangerous, painfully plucking our eyebrows, dieting despite hunger pains, putting uncomfortable concoctions on our faces and wearing fur coats in the summer and mini-skirts in the winter.

From time to time, members of our society have protested against irrational, dangerous, non-functional and unnecessary adornment. Mrs Bloomer's fight against the cumbersome crinoline in the 1850s and the Men's Dress Reform Party's campaign in the 1930s against starched collars and other uncomfortable attire are two well-known examples. More recently, we have seen some members of the Hippy cults of the 1960s reject elegant, formal or fanciful finery as bourgeois trappings,

insisting instead on the merits of casual, practical gar-
ments such as denim jeans. However, as happened
with Mrs Bloomer's bloomers and the 'casual attire' of
the Men's Dress Reform Party, the Hippies' denim jeans
soon became a form of adornment unto themselves.
Meticulous attention to fit and artistic patching converted
Levi Strauss' practical denim work-pants into coveted
art objects.

Perhaps the most ambitious attempt to create prac-
tical clothing bereft of frivolous adornment occurred in
Communist China. The revolution was hardly over be-
fore it became apparent that a true change in Chinese
society would demand changes in clothing and attitudes
towards adornment:

*No directives were actually issued but it became tac-
itly understood by ordinary people that it was not patri-
otic to dress smartly, life was now a serious business
and clothes were a frivolity out of keeping with the spirit
of the times, women put away their smart ch'i p'ao, silk
stockings and high heeled shoes and wore their shab-
biest clothes, cosmetics were no longer used and jew-
ellery disappeared.*[10]

Gradually, however, new forms of adornment accept-
able to the new regime began to appear:

*Although the traditional [unadorned] gown, or at any
rate its modified version, appears confirmed in a linger-
ing survival in the New China it seems obvious that the*

[10]Scott, A. C.,'The new China' in *Roach and Eicher*, p. 130.

print frock and blouse with skirt will replace it as universal garments of feminine attire. The tendency has been marked for some time and now that the Peking government has sanctioned the manufacture of colorful dress materials there is likely to be a wholesale adoption of these styles. A noticeable feature is the use of smocking, embroidery and colored sashes which smack . . . of the peasant styles of Eastern and Central Europe. A foreign visitor to Canton from Hong Kong recently commented on the gay skirts and dresses being worn by the women . . .[11]

Finally, belatedly acknowledging the practical necessity of the seemingly frivolous and counterproductive, on 1 March 1956, Peking announced that the People's Republic of China had held its first fashion show.

[11] *Ibid.*, p. 134.

Chapter 2

Fashion -v- Anti-fashion

The fashion show of the People's Republic of China obliges us to examine and redefine the term 'fashion'. Although adornment and fashion are often used as synonyms, this is clearly neither accurate nor useful. The time has come to subdivide the generic subject of adornment into two separate types: *fashion* and, on the other hand, *anti-fashion*. The gist of this differentiation is contained in Flügel's distinction, made in 1930, between 'modish' and 'fixed' types of dress:

The distinctions here implied are not so much matters of race, sex, or cultural development, but depend rather on certain differences of social organisation. In their actual manifestations, the differences between the two types become most clearly apparent in the opposite relations which they have to space and time. 'Fixed' costume [anti-fashion] changes slowly in time, and its whole value depends, to some extent, upon its permanence; but it varies greatly in space, a special kind of dress tending to be associated with each locality and

*with each separate social body (and indeed with ev-
ery well defined grade within each body). 'Modish' cos-
tume [fashion], on the other hand, changes very rapidly
in time, this rapidity of change belonging to its very
essence; but it varies comparatively little in space, tend-
ing to spread rapidly over all parts of the world which
are subject to the same cultural influences and between
which there exist adequate means of communication.*[1]

Although fashion and anti-fashion are both forms of
adornment, they have little in common other than the
general functions discussed in chapter 1. We can be-
gin to appreciate the specialized functions of each sim-
ply by examining two gowns which were in the public
eye during 1953: Queen Elizabeth II's coronation gown
and one from Dior's 1953 collection. The Queen's coro-
nation gown is traditional, 'fixed' and anti-fashion; it was
designed to function as a symbol of continuity, the con-
tinuity of the monarchy and the British Empire.

Dior's gown also created a stir in 1953, but then
Dior had been creating a sensation since 1947, when
he boldly launched the 'New Look', which defied cloth
rationing in favour of longer, fuller, very feminine gowns.
And each year Dior created a new New Look. In coro-
nation year, he left behind his 'immediately successful
"princess line" with dresses fitted through the midriff,
waist unmarked'[2] and 'reintroduced padding over the
bust with his "tulip" line, and captured headlines by
shortening his skirts to 16 inches from the ground – still

[1] Flügel, pp. 129-30.
[2] Howell, Georgina, *In Vogue*, Allen Lane, London, 1975, p. 227.

two or three inches below the knee. Women were by now used to wearing skirts almost to their ankles, and were nervous of a change that might date their clothes as suddenly as the New Look did in 1947. . .'[3] Likewise, in 1954 Dior changed the 'tulip line' into the 'H line', and in 1955 replaced the 'H line' with the 'A line'. In this way he captured the essence of fashionable attire: its function as a symbol of change, progress and movement through time. Like any fashionable (modish) garments, Dior's 1953 'tulip line' announced that a new season had arrived. Anti-fashion adornment, on the other hand, is concerned with time in the form of continuity and the maintenance of the status quo. Fashion and anti-fashion are based upon and project alternative concepts and models of time.

In his famous ethnographic study of *The Nuer* (a Nilotic people of the Sudan), E. E. Evans-Pritchard, one of the founding fathers of British anthropology and an opponent of Malinowski's functionalist school, included a chapter dealing with Nuer concepts of time and space. His argument, building upon the ideas of Émile Durkheim, was that these concepts reflect and express the patterns of social organization and relationships which are accepted as correct and proper by the Nuer.[4]

[3] *Ibid.*, p. 231.

[4] '... time-reckoning is a conceptualization of the social structure and the points of reference are a projection into the past of actual relations between groups of persons. It is less a means of co-ordinating events than of co-ordinating relationships ...' Evans-Pritchard, E. E., *The Nuer*, Oxford University Press, 1968, p. 108.

Time, as Evans-Pritchard appreciated, is a socio-cultural concept which reflects and expresses a society's or a person's real or ideal social situation. This principle is clearly echoed in fashion and anti-fashion as alternative models of time. If traditional, anti-fashion adornment is a model of time as continuity (the maintenance of the status quo) and fashion is a model of time as change, then it is appropriate that Queen Elizabeth II should not have chosen a fashionable gown for her coronation. It is rational that she should have worn a gown which proclaims a message of continuity over hundreds of years, a message of timelessness and changelessness. In short, her social, economic and political situation suggests that she should prefer things to change as little as possible, and she expresses this attitude in her dress and adornment – especially at her coronation.

On the other hand, a social climber who is, or would like to be, 'on the way up' will use the latest fashions to reinforce and project an image of time as change and progress. His or her fashionable attire constitutes an advertisement for socio-temporal mobility and will remain so as long as he or she stands to benefit from social change rather than from the maintenance of the social status quo.

That form of clothing and adornment which we have identified as fashion has, in fact, always been linked with those situations of social mobility where it is possi-

ble to be a social climber. In Europe, up to and including the Early Middle Ages, the rigid feudal system made such mobility highly unlikely and, accordingly, serfs and noblemen each had their own fixed anti-fashion costume. However, well before the Renaissance, a number of elements converged to create a socio-cultural environment suited to the development of changing fashion. The costliness of the Crusades, the population decline brought by the Black Death and other factors had weakened the power of the aristocracy and increased the power of the 'lower orders'. Frequently the nobility were forced to pay off their debts with money gained by selling serfs their freedom. With the further development of towns and cities, trade, commerce, education and travel created opportunities for these freemen to better themselves and to compete in wealth and power with the aristocracy.

This conflict between the rising bourgeoisie and the landed nobility was often fought with weapons of bodily decoration and adornment. To protect themselves, the nobility enacted sumptuary legislation to ensure the exclusivity of their attire. But these laws were often unenforceable, and furthermore, instead of simply copying the particular fixed costumes of the aristocrats, the rising bourgeoisie increasingly opted for constantly changing fashions.

This system of stylistic mobility – fashion – was an appropriate and logical expression of the social mobility

which was implicit in the breakdown of the feudal system. As Flügel commented, 'fashion implies a certain fluidity of the social structure of the community. There must be differences of social position, but it must seem possible and desirable to bridge these differences; in a rigid hierarchy fashion is impossible.'[5]

The fashion/anti-fashion distinction, therefore, is concerned with changing and fixed modes of adornment respectively. Furthermore, changing fashion 'looks' reflect and express changing, fluid situations of social mobility, while anti-fashion styles reflect and express fixed, unchanging, rigid social environments. It is important to emphasize, however, that, as regards both social and stylistic change, we are concerned not with any quantitative, measurable, objective rate of change, but rather with impressions, perceptions, assumptions and the ideology of change and progress.

It has often been pointed out that fashion change, if looked at over a period of centuries, is cyclical, with themes and looks being repeated every few decades. Nevertheless, the impression that each and every new season's fashion is a fresh 'New look' is as strong as the impression that anti-fashion styles are traditional and unchanging – even though we know that traditional societies and fixed, anti-fashion costumes must, obviously, undergo gradual evolution over long periods of time. Just as the British monarchy has changed over

[5]Flügel, p. 140.

several centuries, so have the garments and regalia worn at coronations. For example, even a casual glance at the coronation robe which Elizabeth I wore at her coronation in 1559 reveals remarkable differences from that worn by Elizabeth II in 1953.[6] Nevertheless, when we look at pictures of Elizabeth II's coronation, the impression, the atmosphere conveyed by the Queen's appearance is such that we feel that she could almost be wearing the clothes of her namesake.

The same principle applies when we consider the fixed folk costumes of peasant and primitive peoples. For example, Petr Bogatyrev in *The Functions of Folk Costume in Moravian Slovakia* (Czech Republic), while arguing that 'the tendency of folk costume is NOT to change – grandchildren must wear the costume of their grandfathers', admits that he is 'speaking here of the TENDENCIES of ... folk costume. Actually we know that even folk costume does not remain unchanged, that it does take on features of current fashion.'[7] He demonstrates how folk costume – especially in those parts of Moravian Slovakia where there is a growing tourist industry – has changed both subtly and dramatically. But this change is clearly differentiated from the phenomenon of fashion change by the attitude of the peasants themselves, who take pride in what they call

[6]See Halls, Zillah, *Coronation Costume and Accessories 1685–l953*, Her Majesty's Stationery Office, London, 1973, p. 6.

[7]Bogatyrev, Petr, *The Functions of Folk Costume in Moravian Slovakia*, Mouton, The Hague, 1971, p. 33.

'our costume' and which they perceive as being absolutely traditional and unchanging. That it does change is to them either unnoticeable or an anathema, and they would not be pleased to be told that their traditional costume isn't what it used to be.

A similar but somewhat more bizarre example of transient anti-fashion costume is to be found in New Guinea. In his definitive study of penis sheaths, the English archaeologist Peter Ucko states that in New Guinea the Telefolmin tribe normally wear as part of their traditional attire penis sheaths made of various types of gourds or large nuts. But now 'the occasional individual is to be encountered wearing instead a toothpaste container, a Kodak film container or a cut-open sardine tin . . .'[8]

Does this constitute a new fashion in penis sheaths? Most probably not. The introduction and development of new technologies should not be confused with true fashion change. Although fashion is not immune to technological advance, it can, and often does, choose to ignore such developments. For example, while fashion in the early 60s delighted in Perspex, Lurex, PVC and various other 'space-age' materials, late 60s fashion made a deliberate change of direction back to natural fabrics such as wool and silk – making the 'clothes of the future' passé while recycling the clothes and materials of the past as a New Look. Equally, Perspex, Lurex and PVC

[8]Ucko, Peter J., 'Penis sheaths: A comparative study' in *Proceedings of the Royal Anthropological Institute of Great Britain and Ireland for 1969*, p. 39.

were technologically available long before they came into fashion. Whether technological advance consists of the introduction of PVC or that of toothpaste tubes, it should not be seen as the same type of phenomenon as fashion change.

Fashion is not simply a change of styles of dress and adornment, but rather *a systematic, structured and deliberate pattern of style change.* This is demonstrated in an essay by the anthropologists Jane Richardson and Alfred L. Kroeber which presents the results of their detailed quantitative analysis of rising and falling hem lengths and other parameters of evening dress design between 1787 and 1936. They show not only that the design of women's fashionable evening dress changes, but that it changes systematically rather than haphazardly, according to what Kroeber calls a 'pattern':

Our first finding is that the basic dimensions of modern European feminine dress alternate with fair regularity between maxima and minima which in most cases average about fifty years apart, so that the full wave-length of their periodicity is around a century ...

There appear accordingly to be two components in dress fashion. One is mode in the proper sense: that factor which makes this year's clothes different from last year's or from those of five years ago. The other is a much more stable and slowly changing factor, which each year's mode takes for granted and builds upon. It cannot be pretended that these two factors are definably distinguishable throughout. Behavioristically, however, they can mostly be separated by the length and regularity of the changes due to the more underlying

component.[9]

Richardson and Kroeber's findings suggest that fashion functions as a system, an internally determined pattern – a mechanism, a structure, a programme – of change. It is possible that this phenomenon has occasionally occurred in non-Western societies, but there is, as far as I know, no information available to prove or disprove this conclusively.[10] It is unlikely, however, that such a mechanism of deliberate change in cloth-

[9]Richardson, Jane, and A. L. Kroeber, 'Three centuries of women's dress fashions: A quantitative analysis' in *Anthropological Records*, vol. 5, no. 2, University of California Press, Berkeley, 1940, p. 148.

[10]Whether or not fashion occurs in primitive or peasant societies is not readily discernible from existing ethnographic reports because field work and field reports are normally done in the 'ethnographic present', in such a way that time and culture change are lumped into the concept of 'now' which anthropologists find helpful. Occasionally, however, different anthropologists happen to study the same tribe or group at different times, and this allows us some grasp of the historical development of the people and culture under study. For example, Andrew and Marilyn Strathern, writing about Mount Hagen (New Guinea), are able to comment that '. . . there are numerous variations in styles of feather arrangements adopted by different groups at a given time; each may change its styles over time, for there is an interchange of styles between groups, and there are also overall changes in fashion which are common to a number of groups – for instance, the older German literature on Hagen shows some items which are not worn nowadays.' (*Self-Decoration in Mount Hagen*, Duckworth, London, 1971, p. 63.) The 'older German literature' to which they refer was written between 1943 and 1948. The Stratherns were writing in the early 1970s. That styles of feather decoration should change over a twenty to thirty year period is hardly surprising, but to justify the use of the term 'fashion' more detailed knowledge of changes in feather ornaments between 1948 and 1970 would, I think, be necessary.

ing and adornment would occur in any traditional primitive or peasant society, where there exists by definition an ideology of the value of tradition and the desirability of cultural stability from one generation to the next – which, of course, is the defining feature of any traditional society.

Only a society organized upon a principle of social and cultural mobility (the rising bourgeoisie) would find a system of structured and deliberate change of dress and adornment to be appropriate, desirable and useful. And while fashion may have developed in conjunction with the rise of the bourgeoisie, once some of these individuals had broken the stranglehold of the landed aristocrats and moved into a newly formed, stable class group (the established bourgeoisie; the landed gentry) they became entrenched as an anti-fashion force.

However, social mobility and fashion, once set in motion, could not be stopped. Great debates have taken place as to whether it is fashion designers, fashion magazines or 'the public' who dictate fashion change. One thing is certain, as Richardson and Kroeber's research shows: once the fashion machine was started up, it developed a will of its own, becoming a continuous system of change which operated and continues to operate according to its own internal structure or pattern.

It is true, of course, that wars, depressions and other such events influence the fashion pattern, but, as Richardson and Kroeber point out in their conclusions:

The explanation propounded is not that revolution, war, and sociocultural unsettlement in themselves produce scant skirts and thick and high or low waists, but that they disrupt the established dress style and tend to its overthrow or inversion. The directions taken in this process depend on the style pattern: they are subversive or centrifugal to it. By contrary, in 'normal' periods dress is relatively stable in basic proportions and features: its variations tend to be slight and transient – fluctuations of mode rather than changes of style. In another civilization, with a different basic pattern of dress style, generic sociocultural unsettlement might also produce unsettlement of dress style but with quite different specific expressions – slender waists and flaring skirts, for instance, or the introduction or abolition of decolletage.[11]

This permits an interesting reappraisal both of fashion and of the relationship of society and culture. Émile Durkheim and Karl Marx shared the belief that what happens on the socio-economic level influences and generates culture (e.g. language, the arts, style/fashion). According to this view, society is like a group of people holding balloons on strings, the balloons representing culture. The movement of the crowd of people determines the movement of the balloons; the balloons do not move the people.

Basically, of course, this is correct, but our analysis of fashion change causes us to add a footnote to Durkheim and Marx. Aspects of culture such as fashion may become organized as internally integrated cultural

[11]Richardson and Kroeber, pp. 149-50.

systems, and this systematic organization dictates its own rules of change which socio-economic and political change can only 'subvert' or 'invert', to borrow Kroeber's terms. Thus fashion change occurs not only with reference to social change, but more directly with reference to the internal, structural organization of the *Système de la mode* of fashion.[12]

The introduction of any fashion innovation must respect and relate to the fashion changes which have come before. In this sense, neither designers nor the fashionable are in charge, directing the course of fashion change. Fashion is to a large extent running its own show, and one can only choose to get on or get off the fashion merry-go-round. If, indeed, even this is really a matter of personal choice. At least until very recent times, throughout history and throughout the world, few could be said to exercise personal *choice* over their appearance – and over an inclination towards the 'modish' or, on the other hand, the 'fixed'; one's socio-cultural situation rather than personality or idiosyncrasy determining your trendy or traditional leanings.

With the exception of the unfashionable (those who can't keep up with fashion change but would like to), *anti-fashion* refers to all styles of adornment which fall outside the organized system of fashion change. The Royal Family, at least in public, wear anti-fashions; Hells Angels, Hippies, Punks and priests wear anti-fashions;

[12]See Barthes, Roland, *Système de la mode*, Semi, Paris, 1967.

Andy Capp and 'The Workers' wear anti-fashions. In no case is their dress and adornment caught up in the mechanism of fashion change, neither do they want it to be. Each wears a form of traditional costume which should ideally, like 'our costume' of the Slovaks, remain unchanged and unchanging. There wouldn't, for example, be demand for or logic to 'this year's New Look' for Hells Angles – a 'tribe' so determined to resist change that, like so many of the tribes studied by anthropologists, they inscribe their culture permanently on their skin.

While anti-fashions most certainly do occur within the context of contemporary 'Western' society, the most readily identifiable forms are the folk costumes of primitive and peasant peoples. In primitive societies, for example, anti-fashion costume plays an important part as one means whereby a society's way of life – its culture – can be handed down intact from one generation to the next. Social and stylistic changes constitute a threat to the maintenance of a particular way of life and a stable tribal identity. Taking things to an extreme, many tribes incorporate within their anti-fashion adornment permanent body arts such as tattooing, scarification, cranial deformation, circumcision, tooth filing, ear, nose and lip piercing, and so on. These permanent body arts are drastic and traditional methods used in part to hold on to at least the illusion of absolute social and cultural stability – an increasingly difficult task in a world where the

changes and transitions begun in our own Middle Ages have become global and pandemic.

Interesting to note, therefore, that so many of the anti-fashion styletribes which have emerged in recent years within our own, rapidly changing world have re-discovered the value of such permanent body arts as tattooing and piercing as effective tools in their own attempts at subcultural stability and as a bulwark against a world where change is forever gathering pace and, in the eyes of many, seems out of control.

Chapter 3

Fashion = Language

Anti-fashion is threatened not only by the spectre of change, but also by the phenomenon of 'fashionalization', whereby traditional costumes or streetstyles are converted into the latest 'looks'. Fashion briefly shines its spotlight of damning praise on one fixed anti-fashion style and then another and leather Biker jackets, peasant blouses, workmen's overalls and even Woolworth's plastic sandals become fashionable. But only for a moment.

During the late 60s, so many diverse anti-fashions became fashionable that it was rumoured that fashion was dead forever – having been replaced by what journalists labeled 'anti-fashion'. In particular, it became fashionable to dress in the styles of the lower or working classes. This was surprising in the light of the fact that fashion has normally been associated with 'dressing up' the social ladder rather than 'dressing down'.

The American writer Tom Wolfe braved exotic places like the Peppermint Lounge in New York City and the Arethusa Club in London to record it all for posterity:

In the grand salon [of the Arethusa Club] only the waiters wear white shirts and black ties. The clientele sit there roaring and gurgling and flashing fireproof grins in a rout of leather jerkins, Hindu tunics, buckskin skirts, deerslayer boots, dueling shirts, bandannas knotted at the Adam's apple, love beads dangling to the belly, turtlenecks reaching up to meet the muttonchops at midjowl, Indian blouses worn thin and raggy to reveal the jutting nipples and crimson aureolae underneath ... The place looks like some grand luxe dining-room on the Mediterranean unaccountably overrun by mob-scene scruffs from out of Northwest Passage, The Informer, Gunga Din *and* Bitter Rice.[1]

I was witness to similar scenes in London in the early 70s – most memorably a party given in honour of Liberace at which our host Sheridan Frederick Terence Hamilton-Temple-Blackwood the 5th Marquess of Dufferin and Ava sported a battered, threadbare, worryingly-stained, lived in and quite possibly died in denim jacket with the words 'Kansas City' scrawled erratically in metal studs on the back. But was this transmogrification of anti-fashion to fashion really something new? And did it signal the collapse of the fashion system? Clearly not:

In the constant search for new styles, fashion absorbs and transmutes forms from other countries and other periods. Prior to the Revolution in France, a belief in the

[1]Wolfe, Tom, introduction to René König, *The Restless Image*, George Allen & Unwin, London, 1973, p. 15.

values and virtues of rural life inspired by Rousseauism gave rise to a sentimental view of peasants and the countryside, and 18th century French court ladies played at being milkmaids, dressed in an idealized costume which included a lace-strewn apron and a cap. After the fall of the monarchy, during the Directoire period, the interest in the democracies of Ancient Greece and Rome was reflected in fashionable costume, which was based on the clothes of that period. The Napoleonic era followed the Directoire period with a passion for things Egyptian as a result of Napoleon's Egyptian campaign and cameos, scarabs, Eastern style turbans and shawls became popular.[2]

In fact, fashion has always appropriated anti-fashion ideas, promiscuously but not indiscriminately, whenever they suited its appetite for change – from the start, military costume a particular favourite source of fashion ideas. Furthermore, in retrospect it is clear that the anti-fashion fashions of the 60s and 70s did not destroy the clean machine of fashion. Quite the opposite: dressing up by dressing down only served as additional fuel to keep the engine of fashion going. To quote the always perceptive Tom Wolfe again: 'Everybody had sworn off fashion, but somehow nobody moved to Cincinnati to work among the poor. Instead, everyone stayed put and imported the poor to the fashion pages.'[3] Despite dungarees, peasant blouses, bowling shirts and a proliferation of kitsch and tacky styles, fashion – even High

[2]Anonymous, 'Costume for decoration' in *Family of Man*, part 34, p. 952.

[3]Wolfe, *Ibid.*, p. 16.

Fashion fashion, with a whiff of Paris in the Spring – was by the mid-70s back in fashion, and the anti-fashions of upper-class society became once again the most popular source of fashion ideas.

Those who in the 60s thought that fashion was dead, that 'fashion is not fashionable any more', forgot that anti-fashion images in the context of the fashion system acquire a new meaning and a new mode of communicating that meaning. Hippy, Hells Angel[4], peasant and worker styles, when worn by the fashionable, are no longer folk costumes or true streetstyle; they are, at least briefly, part of the fashion system. The style may remain much the same – indeed, it may even be the same garment as in the case of the 'Kansas City' denim jacket – but its significance has been changed drastically.

Fashionalization converts 'natural' anti-fashion style symbols into arbitrary 'linguistic' signs. That is, within the context of fashion, anti-fashion images lose their symbolic meaning and become – like phonemes in verbal language – arbitrary building blocks of the system of meaning that we have called fashion. In this way, anti-fashion images are incorporated into the vocabulary of the fashion language.

An example: in the early 70s fashion's search for dressing-down anti-fashions led it down the social lad-

[4]Could someone please contact the Hells Angels and point out that they are missing an apostrophe? Thanks

der to the antithesis of respectability, the prostitute or 'tart'. During this period, St Martin's College of Art in the centre of London had studio and workshop space for its fashion design students in Soho, one of London's traditional centres of prostitution. Given that, for one 'season', many of the St Martin's female fashion students adopted the anti-fashion fashion of the 'Tart Look', there were at this time in Soho girls who looked like prostitutes and were prostitutes and, on the other hand, girls who looked (sort of) like prostitutes but were actually students of fashion design. As might be expected, this caused considerable confusion. The students were shocked at being propositioned so frankly, while the men who tried to buy their services were confused and baffled by the students' responses. They did not understand that an anti-fashion style – in this case the prostitute's traditional costume – does not, on the back of a fashionable art student, carry the same meaning as it does on the back of a real prostitute. Fashion is an arbitrary language system where things are rarely what they appear to be.

This point becomes clearer if viewed from the perspective of semiology, the study of signification and communication first formulated by the Swiss linguist Ferdinand de Saussure. Semiology provides a framework for understanding an extraordinary range of different types of communication systems regardless of their medium of expression and regardless of whether or not they are

'language-like' in a strict sense of the term. Semiologists distinguish between signs and symbols. Signs are arbitrarily related to the ideas and concepts which they communicate. For example, the word 'whale' is a small word for a large concept-object, while 'micro-organism' is the reverse: neither word looks like that which it represents. In arbitrary language systems, different words (signifiers) can be arbitrarily substituted for the same concept (the signified). That verbal language is generally arbitrary is obvious in light of the fact that the word for a whale, for example, may be radically different in different languages, and in that none of these words, regardless of the language in which they are written or spoken, look or sound like a whale.

Symbols, on the other hand, are 'naturally' (that is, non-arbitrarily) related to that which they signify. They are pictorial representations, icons. Thus a drawing of a set of scales may symbolize the concept of justice, and another image, for example a picture of a whale, could not be substituted for it without both images becoming arbitrary signs whose meaning is established only by the 'artificial' conventions of language. Further understanding of the fashion/anti-fashion distinction is provided by applying the sign/symbol, arbitrary/iconic distinction to these two forms of dress and adornment. Anti-fashion is composed of body, adornment and clothing symbols – symbols which have clear iconic meaning within a given culture but which are unlikely to translate

successfully when considered from a cross-cultural, global perspective; symbols which reverberate with a 'natural' meaning which comes from their enmeshed layering within one particular social construction of reality.

Fashion, on the other hand, is a unified system of arbitrary body, adornment and clothing signs. A girl who looks like a prostitute and is a prostitute is a walking anti-fashion style symbol. With her body posture, gestures, movement, make-up and clothing she pictorially represents (symbolizes) what it is that a prostitute is supposed to 'mean'. This anti-fashion image could not be arbitrarily exchanged with, for example, the anti-fashion image of a nun without converting both of these natural style symbols into arbitrary signs. The brightly painted lips, the exposed cleavage and the short, thigh-revealing mini-skirt or tight crotch hot pants of the prostitute combine to form a symbol, an icon of sexual availability and provocation.

On the other hand, the art student dressed like a tart or prostitute does not in her style mean 'I am sexually available'. Her message is simply 'I am fashionable'. Three months ago she may have looked like Chairman Mao, and in six months time she may look like an innocent adolescent schoolgirl. In fashion, various styles are linked together as parts of a system in which meaning is gleaned from the structure: as with a join-the-dots puzzle, it is only when sufficient fashion images are joined together in sequence that a message becomes

apparent. A message moreover which is always and everywhere the same: the world is in flux, this change equals progress, everything is constantly and forever getting better and better.

When fashion is dealt with in this way – as an integrated system – not only is a message discernible amidst the apparent absurdity of the parade of arbitrary, meaningless fashion images, but it becomes evident that this message cannot be dismissed as either frivolous or insignificant. Fashion is an advertisement for the ideology of social mobility, change and progress, a message which is symbolized by the fashion system's own mechanism of constant change – a system, a machine, a pattern or programme for the generation of looks which are desirable and stimulating to those for whom change, progress and social mobility are themselves desirable and stimulating.

Those who see change, progress and revolution simply in terms of a class struggle and who see fashion as simply the prerogative of the rich upper class or of the bourgeois middle class may find it difficult to fully appreciate the perpetual motion dynamics of the system which is fashion. In the past, styles associated with particular class groups (including the working class or peasants) have become fashionable but the presumption that the fashionalization of any class's style means that the fashionable are members of that particular class is as erroneous as the presumption that the Tart Look

signalled that the followers of this fashion had all become prostitutes. Our host at the party given in honour of Liberace in the early 70s – Sheridan Frederick Terence Hamilton-Temple-Blackwood the 5th Marquess of Dufferin and Ava – was employing his battered 'Kansas City' denim jacket to signal that, despite his aristocratic status, he liked to dabble in (anti-fashion) fashion rather than that he had become a left-leaning revolutionary. The process of fashionalization represents a transition from symbols to signs, and the conflict of fashion and anti-fashion is, in semiological terms, a battle of signs versus symbols. Sociologically, such fashionalization represents not the triumph of one class over another but rather the triumph of fluidity within and throughout a hierarchical structure which itself remains fully intact and intransient.

However, the systematic patterning of fashion signs over time spins out a thread of meaning with non-verbal sentences linked end to end to form paragraphs and whole volumes of fashion history. Thus, ironically, while particular, specific, individual fashion images are arbitrary signs, the structured pattern of fashion change is in its totality a 'natural' symbol of social change. Fashion is able to accomplish this because it is, like any language, a system, and by virtue of its structure (syntax) being more than the sum of its parts. Indeed, the fashion system provides the perfect 'natural' symbol of a social system based upon change and social mobility.

An understanding of the fundamental structure and underlying grammar of the fashion language has long evaded those who have sought a magic formula to predict fashions. We do know, however, that the fashion language is organized around one rule which determines that each season's clothes should be perceptibly different from last season's 'look' and another which ensures that this seasonal change fits within the overall parameters of the fashion system's deeper structure. A full grasp of the structure – grammatical rules, progamme – of the fashion language is not yet possible, although its practical applications would make it highly desirable. But then a system based upon a chameleon-like ability constantly to adapt would easily evade detection and entrapment by simply altering its pattern, thereby both protecting its single message of constant change and preserving us from the dull disappointment of total predictability.

Chapter 4

Anti-fashion = Identity

The nature of a language system always reflects the social environment of the people who 'speak' it. Fashion is the natural, appropriate language of the socially mobile, those between rather than within traditional social groups. While symbolizing social mobility and change, fashion also symbolizes the social rootlessness, anomie, alienation and atomization which are products of this social change. Fashion's function is to represent and identify the social and cultural limbo of modern urban society, where more and more people are on the move between the lower and middle classes or the middle and upper classes, or within the middle class. Many of us find it difficult to identify ourselves socially. The old categories no longer seem to apply. Here is, and always has been, the spawning ground of fashion – at least where the perception is that such social mobility is in an upwards rather than a downwards direction.

Where some might see only uncertainty, anomie and alienation, fashion expresses the positive aspects of this state in that it is a celebration of mobility, fluidity and progress. This celebration is threatened by the possibility of stylistic or social stagnation. Stylistic stagnation occurs whenever new fashion ideas are not forthcoming and fashion's mechanism seems in danger of running out of steam. Social stagnation in this context occurs whenever stable social groups crystallize within the fashion world.

For example, many successful 'fashion' designers become associated with a particular look and a particular social clique which adopts this look as its anti-fashion costume. When this occurs we find anti-fashion masquerading, or at least wrongly identified, as 'fashion'. The extent of this phenomenon has caused considerable confusion regarding that which is fashion and that which should more accurately be described as *style*. Thus, although 'Gucci is an international status symbol ... and the GG monogram a badge of membership in the good life',[1] it, along with many of the styles regularly advertised in *Vogue, Harper's* and other arbiters of good taste, has nothing to do with fashion in any strict sense of the term – a brand like Gucci, Burberry, Armani and a host of others focused on maintaining a 'timeless' signature style rather than parading an endless succes-

[1]Kaori O'Connor (ed.), *The Fashion Guide 1976*, Farrol Kahn Ltd, London, pp. 86-7.

sion of new New Looks and novelty for its own sake. If there is greater, more obvious difference between designer A and designer B than there is between designer A or designer B's output from one year to the next than we are within the world of style rather than fashion.

On the other hand, those who seek within the context of true fashion an 'in crowd' which constitutes a true socio-cultural entity must always be disappointed – for the fashionable are not a social group but rather the *category* of those who fall *between* social groups. This distinction between social group and category hinges on the fact that members of groups actively accept group identification by agreeing to operate according to the rules of that social system. Fashion – the systematic generator of style fluidity – is an appropriate expression of movement through society. Those who disembark from this social and stylistic roller-coaster ride give up the freedom of social mobility for the security of social stability, and the adventure of perpetual fashion change for the reliable steadfastness of 'our costume' and comforting inclusion within an 'Us'.

Identification with and active participation in a social group always involves the human body and its adornment and clothing. Being a Nuba, a Beatnik, a Hasidic Jew, a Hells Angel or a Hippy involves looking like a Nuba, a Beatnik, a Hasidic Jew, a Hells Angel or a Hippy. Furthermore, as we said before, the particular style which each group adopts as 'our costume' is

not arbitrary and is not interchangeable with the style of other groups: Hells Angels could not dress like, for example, the Hare Krishna people and still visually communicate the ideology of the Hells Angels, and vice versa. It is in this way that anti-fashion styles are appropriate social symbols. They state not only that 'we' exist (i.e. that 'we' are a group), but they also express symbolically what kind of group it is that 'we' are.

When an individual agrees to identify with and become part of a particular social group, s/he automatically agrees to accept that group's ideas about what constitutes respectable, appropriate attire. This is not to suggest, however, that every member of a social group will wear an identical uniform. In a sense, everyone – most of all the fashionable – wears some sort of uniform, but even in the army no two uniforms are absolutely identical or worn in precisely the same way.

In so far as members of a social group share a 'collective consciousness' (Durkheim), a common 'sociologic' (Levi-Strauss), a collective 'ideology' (Marx), they will share ideas within their group about what constitutes proper dress. But these ideas only set guideline limitations. Within a social group, the precise definition of proper dress may vary from time to time, from place to place and from person to person. But even where a wide degree of variation is tolerated, there are always ultimate rules of appearance which cannot be breached without the violator being ostracized. Dress

codes – even if they are unstated, as is usually the case – precisely describe the limits of social groups. Those who breach the guidelines (e.g. Hippies in suits, Skinheads with long hair) are not 'one of us' – not 'our kind of people'.[2] Thus, except in the case of fashion (which is stylistically and socially promiscuous), style groups are social groups.[3] Within each group, there is at least the presumption of agreement on the basic issue of 'our way of life', and this is inevitably expressed symbolically in 'our costume'.

The principle that social groups are anti-fashion style groups and that these styles symbolize 'what we are' applies to any type of social group, no matter how small or short-lived, towards which there exists a sense of group identification and belonging. Tribal groups are an obvious case in point. All the thousands of tribes which anthropologists have studied (the Nuba, the Nuer, the Apache, the Masai, the Hopi, the Swazi, etc.) have distinctive anti-fashion tribal costumes. Each particular style is a symbolic statement of that particular tribal group's principles of social organization and accepted way of life (i.e. culture). As such, these visual tribal symbols are non-interchangeable, unique and appropriate socio-stylistic expressions. We who are not mem-

[2]See Owens, Bill, *Our Kind of People*, Straight Arrow Books, San Francisco, 1975.

[3]Aside from fashion, the other interesting exception to the thesis that style groups are social groups (and vice versa) concerns those situations in which a group must remain a secret society such as, say, the French Resistance or the CIA (*Men In Black* excluded).

bers of these groups may not fully understand their message, but we cannot deny their significance.

Likewise, the same principle – that a social group and its collective ideology are represented by an anti-fashion costume – applies to any sub-groups or, in the contemporary West, streetstyle 'tribe' found within the broader society. Each separate caste group of Indian society has its own stylistic identification. In modern Western society we have class rather than caste groups, but these – where they still exist – are also style groups as well as social groups. The upper, middle and lower or working classes of British and American society have all expressed themselves in particular, appropriate anti-fashion styles, and historically class conflicts have been most visible in stylistic conflict, compromise and dogged resistance to compromise.

No matter how small a group is, its members will always attempt to develop a visual style – 'our costume' – with which to advertise themselves as a group. For example, traditional societies in Greece, Romania, Bavaria and a host of other countries were (and in many places still are) subdivided into various village or neighbourhood groups; Nuba society (Sudan) sub-divides into various age grade groups, etc. In each instance the existence and boundaries of these sub-groups are traceable according to unique stylistic features which are a 'natural' expression of each sub-group and its situation in society as a whole. In this way stylistic differences

of body decoration and dress serve – and have always served throughout human history – to effectively colour code the structures and processes, boundaries and ideals of any and all social systems. No doubt the simple efficacy of this system helps to explain why our species became the one and only decorated ape.

The declining importance in the urban West of village-neighbourhood and clan-family groups is obvious on a stylistic level. Bogatyrev in his discussion of folk costume remarks that 'the whole of Moravian Slovakia is divided into 28 costume districts' and 'in the old days each parish had one single type of costume'.[4] But in contemporary Western urban and suburban social environments, little in the way of a neighbourhood costume can be found. In the same way, the breakdown of extended family groups in modern industrial society becomes apparent when we consider stylistic indicators. And the increasing stylistic diversity amongst young people suggests that 'youth' is a demographic category but not a true socio-cultural group. In primitive and peasant societies, large extended family groups such as clans are often an important focus of social and cultural identity. Where this is the case the members of a family group will, at least on special occasions, distinguish themselves from other family groups in their dress and adornment. The same was of course true in traditional Scotland where each clan had its own distinctive tar-

[4]Bogatyrev, pp. 54-5.

tan. In the West today, few if any of us would dress 'like a Smith' or 'like a Jones'.

On the other hand, other forms of group affiliation have become increasingly important in contemporary Western society – in particular those involving identification with a specific subcultural worldview which is expressed in dress, adornment and often music and often with a distinctive, charismatic individual like, say, James Dean, Connie Francis, David Bowie, Johnny Rotten, Dolly Parton or Becky Bondage who serves as a model which all those who identify with a particular group will try to emulate both ideologically and stylistically. (Style and ideology always two sides of the same coin.) It's interesting and important to note that today a single demographic like age no longer determines which style models are emulated with the result that teenagers of exactly the same age and living in the same neighbourhood may end up looking completely different. Throughout most of human history one belonged to a sociocultural group and your membership of that group determined your appearance style. In the world today, increasingly, lacking any sense of socio-cultural identity but, on the positive side, having unprecedented freedom in matters of appearance, we adopt a look as a first, symbolic step in the process of, hopefully, obtaining a sense of membership within a social group or network. Where once style followed on from society, now it is the reverse.

However, stylistic allegiance to these contemporary 'styletribes' is frequently transient, in sharp contrast to the permanent and total allegiance which is a requirement of membership in, for example, a tribal society. Historically, to signify this kind of permanent membership, superficial changes of clothing, adornment or hairstyle were not enough. In traditional societies it was not only external garments which were employed in stylistic identification; the body itself was 'customized' in terms of both appearance and behaviour – by the time an initiate had been properly socialized his or her manner of walking, posture, gestures, demeanour, hairstyle, body decoration (both transitory and permanent) and clothing all fit together like the pieces of a jigsaw puzzle to reveal an image of 'our way of life'.

In this way traditional societies attempted to perpetuate themselves by handing down the message of 'what we are' from generation to generation. Traditional societies are by definition conservative: they seek to preserve their culture against the threat of change and instability. Anti-fashion, especially where the body is permanently customized, is the most intimate and thereby the most powerful weapon with which a society can protect itself against change. Anti-fashion is a time capsule which one generation leaves for the next, a machine designed to symbolically defy and destroy change.

Increasingly, in Western society, the mechanism of anti-fashion is proving unsuccessful in maintaining socio-

cultural continuity. In fact, the stylistic disjunction of fathers and sons and mothers and daughters has provided a powerful and unavoidable reminder of the generation gap. When, in the 60s, many American, British and European adolescents refused to get their hair cut and developed their own alternative style, it soon became apparent that these superficial stylistic divisions were indicative of a much deeper fragmentation of our society, culture and way of life. From this moment on it was clear that lifestyle choices rather than the circumstances of one's birth – your class, religion, nationality, race, ethnicity – would be the critical factors in delineating, defining and creating 'our kind of people'.

Chapter 5

The Politics of Style

We have seen that the fashion system in its totality is a symbol of change and social mobility, whereas anti-fashion styles are markers of social identification and cultural symbols. We have applied this argument to various types of social group ranging from large social systems (e.g. tribes) to a variety of those smaller sub-groups which exist in their shadow. It now remains to consider the interrelationship of all these types of social-style groups.

In traditional societies, the integration of macro and micro group affiliation is institutionalized and an individual experiences no difficulty in integrating the various levels of his or her social and stylistic identity because membership in, for example, a tribal group is perfectly compatible with and complementary to membership in the appropriate kinship and age set groups within the broader social system.

Sometimes this harmonious integration of multiple style-group identification also occurs in modern, 'complex' societies. It is possible, for example, for a man to indicate his membership of the middle class through his suit, his educational group through his old school tie, his political party through a campaign button and his religion by wearing a cross tie-pin – all without contravening the dress codes of any of these groups. But increasingly we are faced with a multiplicity of ideologically and stylistically incompatible groups. In such a situation there has developed competition between alternative groups which finds expression in the arena of the politics of style.

Some of these alternative socio-style groups find themselves economically, politically, ideologically and stylistically dominated by other groups which are considered 'normal' and 'natural' simply because they are in power. Karl Marx suggested that ideological manipulation always follows in the wake of economic and political domination. He did not say as far as I'm aware, but it is obvious, that appearance (as an expression of ideology) may also be manipulated, thereby producing a false consciousness of style in which people must dress not in the style of the group or sub-group with which they identify socially, ideologically and aesthetically but in the style prescribed by the dominant social body.

Historically, a classic example of the politics of style occurred when, in the aftermath of the Jacobite Risings,

the government of King George II outlawed all items of traditional Scottish Highland dress including the kilt in the 'Dress Act' of 1746. In today's world, for most of us, the politics of style operates primarily in a demarcation between the 'normal' and the 'abnormal'; between 'respectable' and, on the other hand, 'deviant' or 'perverse' ways of styling, clothing (or not clothing) and adorning the body. Some alternative style-ideologies are tolerated but even innocent humour reveals how fearful society at large is of some style minorities. The nudists are one case in point – although we may have forgotten today how long and hard they once had to fight for their place in the sun. But, while this group has gained a certain level of acceptance, many other groups, such as the Mackintosh Society, have a long battle ahead of them before their costume can even be discussed without derision.

The Mackintosh Society is an interesting example both of the interplay of group, ideology and style and of the repression (if only in the form of mocking) of unacceptable minority style groups. In the sex correspondence magazine *Relate*, Mr Leon Chead answers the question 'Does the Mackintosh Society really exist?':

The Mackintosh Society, yes, it exists and is growing in membership every year, and bringing mackintosh and rubber enthusiasts together from all corners of the world. Founded six years ago with the aim of bringing enthusiasts together to talk openly with fellow rub-

*berists, to enable them to correspond with one another
... and to try and break down the guilt ridden attitude
that existed for many years within society at large with
regard to people who were attracted by, and who like
rubber mackintoshes and clothing.*[1]

There is no reason to suppose that the Mackintosh
Society is any less a true social group with its own 'our
costume' than, for example, a motorcycle gang. No
doubt there are differences within the group on the ques-
tion of mackintoshes versus capes, thick rubber outer
coverings versus thin, skin-tight inner costumes, and
so on. But beyond these differences of opinion, there
exists nevertheless a common belief in the value and
desirability of rubber clothing as opposed to any other
type of garment. Rubber and the 'bizarre' costumes
into which it is made constitute the non-verbal ideologi-
cal manifesto of the Mackintosh Society. Like all social
groups, the 'Mac Soc' is simultaneously a social and a
style group, and the rubber medium is the embodiment
of its social message.

This message may be obscure, however, to those
who are not familiar with the sex correspondence mag-
azines. In *The Relate Rubber and Leather Handbook*,
Mr J. D. of Birmingham explains how 'my biggest thrill
was when I managed to sneak to bed with my eldest sis-
ter's white rubber cape. It was so large and enveloped

[1]Chead, Leon, 'Does the Mackintosh Society really exist?' in
Relate, vol. 2, no. 2, p. 27.

me fully.'[2] Likewise, Mrs J. M. of Bucks, writes: 'My husband's favourite is to have me engulfed in rubber bra, panties, corset, petticoat, stockings, gloves, dress or blouse and skirt and double breasted mackintosh buttoned to the neck plus my rain helmet.'[3] Mrs S.O.F. of Cornwall is pleased to have a husband who does not allow her to wear non-rubber clothing without his specific consent. She lives in a complete and wonderful 'rubber world':

I am led to the rubber covered bed in the spare room, lying on it, eyes closed as the eye strap is zipped and locked. Now my ankles please, I think, as through my rubber skin I feel the straps stretching my ankles to each comer of the bed. Then wrists. Now Peter is gone, and I am alone in my tight secure rubber skin. I often wish I really had a rubber skin, rubber lips, rubber tongue. I lie unfree and yet free in the glorious warm excitement.[4]

Rubber 'engulfs', 'encases', 'envelops', 'binds'. In short, it dominates the rubber fetishist and makes him or her a 'rubber slave'. In the iconography of an ideal rubber world we find symbolic images of a submissive Utopia founded on principles of loving and consensual 'control', 'domination' and 'humiliation.' It is, however, a very different type of domination from that symbolized by, for example, leather garments. Leather is usually thought of as tough rather than pliable and is associated

[2] *The Relate Rubber and Leather Handbook*, p. 63.
[3] *Ibid.*, p. 72.
[4] *Relate*, vol. 3, no. 9, p. 37.

with an aggressive quality which is completely opposed to the 'passivity' of rubber. To the bulk of the population of Western society, however, neither rubber nor leather fetishist styles express an acceptable lifestyle or worldview. The 'free society', eager to protect its own image-style, publicly frowns on both the dominated and the dominator.[5]

Whenever there exist two or more groups in competition with one another, there will always be a politics of style. When one group-ideology-style is in a dominant position, all other group-ideology-styles will be repressed, ridiculed and, in some cases, labelled 'obscene' or 'pornographic'. But obscenity and pornography are obviously culturally defined and generated concepts: a Renoir nude is now respectable, whereas the 'obscene' may, as with the Mackintosh Society, be completely clothed.[6]

Stylistic repression is not of course unique to the West. In 'The Third World', Western imperialism created an imperialism of Western dress, and the indige-

[5]Interesting to note from the perspective of the 21st century that the advent of 'fetish fashion' clubs in the 80s and 90s (first in London, then throughout the West) would in time give both leather and rubber fetishists a chic cachet which was unimaginable when *Fashion & Anti-fashion* was written in the late 70s. For a more detailed discussion of this phenomenon and its history see the chapter 'Pervs' in my book *Streetstyle* (London, 2010).

[6]In the 21st century, the issue of banning the burka could be considered within the context of this same discussion – the unacceptability of dress which, the opposite of traditional concerns about modesty, covers too much. Surely such legislation is an affront to any notion of the freedom of self-expression.

nous ruling elites which emerged in the wake of the collapse of colonialism usually held strongly pro-Western ideologies and insisted on the desirability of Western styles of dress. Furthermore, these ruling elites often attempted to impose their ideas of Western dress upon the populace. In his article 'The robes of rebellion: Sex, dress and politics in Africa', the African historian Ali A. Mazrui describes how the ruling elite of Tanzania attempted to legislate formally against the traditional dress of the Masai tribe:

'Far away, many dust-laden miles away in Arusha some little man in the administration, such as are to be found in all the governments the world over, in his little white shirt and collar and his little Western tie, or in his national dress that gives him prickly heat around his neck whenever the weather gets excessively hot and humid, has decided that the Masai must wear clothes.'

This bitter lament against the new policy statement from Tanzania early in 1968 formed part of the debate which was unleashed by the declaration of that policy. The authorities in Tanzania had decided that the Masai had been permitted naked indulgence for far too long; that their withdrawal from normal attire constituted a withdrawal from the mainstream of progress in their countries. It had therefore been decreed that no Masai men or women were to be allowed into the Arusha metropolis wearing limited skin clothing or a loose blanket. The Maasailand Area Commissioner, Mr Iddi Sungura, kept on issuing a number of warnings to the Masai threatening retribution if they clung to awkward clothing and soiled pigtailed hair.[7]

[7]Mazrui, Ali A., 'The robes of rebellion: Sex, dress and politics

The 'naked indulgence' of the Masai is, of course, in the eye of the Westernized elite. Obviously, the Masai themselves see their tribal costume as respectable and natural. Their dress is an integral part of their tradition, and represents for them an appropriate symbol of their tribal identity. Politically, the situation is simply one in which an alien style is being forced upon a tribal group which has been stripped of its power by events beyond its control.

Any style-ideology will be ridiculed or, where politically feasible, repressed if it is in some way a threat to the existing social norms and cultural ideals. Repressed social groups, being unable to alter the existing social situation, are often reduced to fantasizing about some imaginary utopia. A repressed alternative corporal style may advertise a utopian vision of some revolutionary 'other world', some other society or lifestyle. Despite opposition from the ruling body or mainstream, these visions often manage to make themselves manifest – for instance, in the contemporary West, in photography, fashion catwalk shows, film, dance, theatre, science fiction and other vehicles of fantasy and mythology. In the clothing and body styles of 'Other Worlds' and of the distant future, there is often encapsulated a rich symbolic image of some alternative way of life.

But if utopian anti-fashion styles describe other ways of life and are revolutionary in the sense that they sug-

in Africa' in *Encounter*, vol. XXXIV, no. 2, February 1970, p. 19.

gest the possibility of change would they not be better described as fashion? The answer lies in the fact that utopian anti-fashion styles propose only one specific change, a single movement from A to B, whereas true fashion is a system of continual and perpetual style-social change – change not towards any particular, fixed end but rather change for the sake of change itself. True fashion never comes to rest; it is a permanent revolution.

Utopian styles are anti-fashion rather than fashion in that they advocate a single change to a new status quo rather than perpetual change. They are always attempts to assert and realize symbolically a particular ideal society. This is not the case with true fashion which never moves towards some specific, fixed, ultimate goal. Anti-fashion symbols, on the other hand, represent society as it is, as it ought to be or, in the case of dystopian styles (i.e. 'monsters'), as it should not be.

Whether real or imaginary, everyday dress or secret apparel, anti-fashion styles are always social symbols, and the politics of social groups is demonstrated in the theatre of the politics of style. Stylistic imperialism, for example in the form of the Miss World Contest with its Western vision of 'normal attire' and 'natural beauty', follows on the heels of social, economic and political gains by the West. It may be, however, that anti-fashion Western styles will in time be rejected and replaced with

national, tribal and 'political' anti-fashions from the Third World. Meanwhile, within the West, racial, class, political, religious and streetstyle 'tribes' compete with one another and with the body politic of the 'best-dressed' men and women.

These social conflicts have generated complex and often chaotic style conflicts. Leather-clad motorcyclists roar past, men in rubber macs and Wellington boots stride by singing in the rain as Flash Gordon conquers the universe in an absolutely divine glittering leotard. Alex and his Droogs check their eye make-up and suspenders before mingling with Teds in Edwardian drapes dripping Brylcreem and Punks in ripped plastic garbage sacks who are furiously backcombing their extraterrestrial/primitive hairstyles just as Ziggy Stardust pops into a phone booth and in a flash emerges as Superman. From *The Land That Time Forgot*, Hippies in buckskins roam the wild West Side of Manhattan – except for Max's Kansas City, where Andy Warhol works on the door checking that everyone is wearing Jockey Classic Briefs. Fashion isn't dead – not yet at any rate – but it increasingly has to share its singular New Look 'direction' with a startling array of alternative, anti-fashion visions of worlds never before imagined.

Chapter 6

Conflict & Conclusion

We can distinguish three types of adornment conflict. The first is the competition between alternative anti-fashion styles – as in the case of tribe X versus tribe Y, traditional working-class versus middle-class styles, Mods versus Rockers, and so on. This type of style conflict is best understood as the conflict between different cultures, worldviews and ideologies as expressed in the form of contrasting appearance style symbols.

A second type of style conflict – also obvious, but not discussed directly thus far – describes the endless squabbles and skirmishes which occur within the ranks of the would-be fashionable. All the participants in this debate would like to have themselves and their designs decreed to be 'the fashion' rather than condemned to the ranks of the unfashionable. In practical terms, this form of style conflict occurs whenever, and to the degree that, there is disagreement about the interpretation

of the rhythms and pattern of fashion change. Interestingly, while fashion in the past had little problem with agreeing, for example, that Dior's 1947 'New Look' was the 'direction' which all should follow, such consensus seems increasingly hard to achieve today.

This brings us to the third and final form of style conflict: fashion versus anti-fashion. This was briefly discussed in chapter 2 but can be considered more fully now that we have mapped out some of the differences between these two forms of adornment in semiological and sociological terms. As we have seen, the conflict of fashion and anti-fashion can involve both these radically different approaches to appearance in incursions into each other's territory. On the one hand, many designers and brands in the 'fashion' industry are actually creators of 'classics' which, strictly speaking, are not fashion at all. It is easy to detect these anti-fashion elements within the fashion scene by asking whether these designs change radically and systematically over time. The fashion designer who year after year turns out variations on the same 'signature' look is not a fashion designer in any meaningful sense of the term. (Surely we now have 'style designers' and a 'style industry' – and, powering this transformation, consumers more interested in consistent, meaningful style than here-today-gone-tomorrow fashion?)

This is often the case when, year after year, a designer becomes strongly associated with a particular

style (e.g. Coco Chanel's suit, Jean Muir's 'little black dress') for which there is a demand and a following – a 'tribe' – which has adopted that style as a fixed costume (and who, significantly, are proud rather than ashamed that they have resisted jumping on the latest bandwagon; interesting how often this includes professionals within the 'fashion industry' itself). For example, although the designs of Coco Chanel were often in vogue/*Vogue*, 'Chanel's was a classic line, refined again and again but never fundamentally changed'.[1] There is, of course, nothing wrong in this, as long as it is appreciated that this is not fashion within any definable terms of reference – for to fail to do so confuses the word 'fashionable' with the more general (and increasingly popular) category of 'stylish'. Indeed, it is important to note that the passing of every year of late has seen a larger and larger percentage of 'fashion designers' and 'fashion brands' finding success as purveyors of timeless classics which in everything but name are sterling examples of contemporary anti-fashion *style*.

But while some elements within the 'fashion world' have drifted into anti-fashion, fashion has been busy making guerrilla raids on the most unsuspecting anti-fashion groups to kidnap a booty of anti-fashion styles and ideas which can be fashionalized and, after a brief spell spotlighted by the glare of the 'In', discarded on the junk heap of un-fashion. It is important to under-

[1] Howell, *Ibid.*, p. 205.

line again the fact that the conflict of fashion and anti-fashion is not between particular styles (e.g. Cavaliers versus Roundheads, Skinheads versus Hippies) or between different designers' 'looks' within a fashion season (e.g. Dior versus Balenciaga). Within fashion and also within anti-fashion, conflict is between look/style A and look/style B. The conflict between fashion and anti-fashion, on the other hand, could be represented as the clash of styles A, B, C, etc. (specific anti-fashion styles) and looks A1, B1 C1, etc. (that is, style A, etc. after fashionalization). The look itself need not change much: the fashionable 'boiler suits' which appeared in Britain in the 70s were, despite minor alterations, still essentially boiler suits as once worn by genuine British workmen everywhere. The look of the garment remains basically the same, but the sociological, temporal and semiological-linguistic context of the style has been radically changed by its fashionalization.

When anti-fashions are fashionalized, what semiologists have called 'natural' symbols are transformed into arbitrary signs which are meaningless as isolated images (it being only within the total fashion system that 'natural' meaning can be found). It is tempting, therefore, and in a sense correct, to see the conflict of anti-fashion and fashion as a conflict of the natural and the artificial. It is certainly true that the rise of fashion in the West – and now, increasingly, the spread of fashion to Westernized countries throughout the world – has

been marked by a simultaneous increase in the extent to which people no longer look like what they are. There is indeed a certain artificiality in this posing: people, as we have seen, may dress like soldiers, prostitutes, athletes, flamenco dancers, Peruvian peasants, cowboys, country squires, gangsters or Maoists without in real life being anything of the sort. It is not surprising, therefore, that fashion is frequently criticized as being 'artificial', 'plastic', 'unreal' and 'unnatural'.

But care must be taken when using such powerful and complex words as 'real' and 'natural'. As a result of the work of Durkheim and Marx, we increasingly appreciate the 'social construction of reality'[2] and that 'natural symbols'[3] are only natural because of the interplay and layering of what Durkheim called 'collective representations' and 'social facts'. We *learn* what is 'natural and real' and what is 'unnatural and fake', and different people in different societies or different historical periods may define these terms and demarcate these territories of meaning in radically different ways. The 'natural' is in fact simply that which resonates within and conforms to all the layers of meaning found within a particular culture. Cross-culturally all but a very few such symbols (e.g. arguably all humans equate the colour red with vitality and, on the other hand, with danger because all

[2]See Berger, Peter L., and Thomas Luckmann, *The Social Construction of Reality*, Penguin, Harmondsworth, 1971.

[3]See Douglas, Mary, *Natural Symbols*, Penguin, Harmondsworth, 1973.

humans have red blood) are revealed to be artificial, culturally-specific, learned constructs.

Furthermore, the sanctity of that which is deemed to be 'natural' and the condemnation of the 'unnatural' are always ideological weapons for preserving a social, economic and political status quo. To decree that something is 'natural' is to attempt to move it outside the bounds of deliberation and critical evaluation. As the anthropologist Mary Douglas has suggested:

Time, money, God, and nature, usually in that order, are universal trump cards plunked down to win an argument. I have no doubt that our earliest cave ancestress heard the same, when she wanted a new skirt or breakfast in bed. First 'There wouldn't be time', and then, 'We couldn't afford it anyway'. If she still seemed to hanker: 'God doesn't like that sort of thing'. Finally, if she were even prepared to snap her fingers at God, the ace card: 'It's against nature .. .'[4]

As an ideological weapon, the argument that a particular appearance style is 'unnatural' is found wherever there is a politics of style. Just as human beings have always adorned themselves and customized the human body (all such adornment and modification, of course, in truth, 'against nature' although, interestingly, adornment and modification of appearance as a general principle is a universal element of 'human nature'), so too they have always commented, from the comfort of their

[4]Douglas, Mary, 'Environments at risk' in Jonathan Benthall (ed.). *Ecology, the Shaping Enquiry*, Longman, London, 1972, pp. 134-5.

cultural caves, on the absurd, 'unnatural things' which other people in other cultural caves do to decorate their bodies. How 'unnatural' to stick a bone through a piercing in your nose unless, of course, you belong to a tribe which has always seen such adornment as *de rigueur* and the epitome of 'natural beauty' – generation upon generation going back all the way to the beginning of time when the great ancestor came down from the sky with a big bone in her nose. From a cross-cultural or historical perspective, however, we can appreciate that 'the natural' is simply any appropriate cultural expression of a particular social world – a 'natural' product of a consonance between social facts and cultural perceptions.

This is as true of fashion as it is of anti-fashion costume – the 'natural' appropriateness of which is decided by the weight of tradition and the manipulation of history as is the way of all established societies. It is because fashion is, by definition, anti-traditional, and therefore lacks the historical rootedness of 'our costume', that it is such an easy target for ridicule and condemnation as frivolous artifice. But, ironically, the social facts of the modern world are turning the tables and undermining the 'natural reality' of tradition itself. The transformations of worldview which began in the West during the Middle Ages and which gained momentum – in particular the conceptual jump to lineal notions of time, the unprecedented equation of change and progress; all,

in sociological terms, rooted in the advance of social mobility and the creation of a middle class – was not just a passing phase but the triggering of a permanent revolution of continuing modernization. A permanent revolution involved not only in the creation of new technologies and socio-cultural change, but a re-orientation towards change itself: as the Argentine sociologist Gino Germani has noted, 'Primitive communities and pre-modern civilizations do not accept change in most of their institutions, while in modern societies change is expected or required. The former institutionalize tradition; the latter institutionalize change.'[5]

In appreciating that tradition is institutionalized – a culture-specific manipulation of the perception of history, time and reality – we can perceive the artificial foundations upon which the 'natural' supposition of 'our way of life' and 'our costume' are based. In recognizing that the increasing modernization of contemporary society has institutionalized change rather than tradition, we can also begin to appreciate that, in the context of the modern age, change and its symbolic representation in the fashion system are appropriate 'natural' expressions of 'the process of modernization [which] is a kind of permanent revolution without any final goal'.[6] (Which, clearly, could have no more perfect – indeed, no more *'natural'* – symbolic representation than that

[5]Gino Germani, 'Industrialization and modernization' in *Encyclopaedia Britannica*, 1974, *Macropaedia*, vol. 9, p. 521.

[6]*Ibid.*, p. 520.

system of clockwork, unending change which we call fashion.)

And so, ironically but accurately, in our constantly changing modern world it is that which is preserved in aspic-like pockets of tradition – the Morris dancers, the ethnographic tourism featuring the 'traditional' costumes and dances of the Masai, Mod revivalists lovingly polishing their retro scooters and so on who, out of step with the 'real world' around them, are best categorized as 'unnatural' and artificial.

But the fashionable have never required or hidden behind apologists. Fashion has never claimed and never sought to be anything more than a towering edifice of artifice, a grand illusion, the longest-running show in the West, the ultimate soap opera serial which has for centuries kept us surprised, amused, outraged and entertained, and is, we hope, perpetually 'to be continued'.

Part III

Postscript to the 2011 Edition

Fashion didn't carry on – it wasn't as my 1978 self imagined, 'to be continued' forever – because that worldview which it so effectively symbolized – modernism – itself faltered and then found itself embarrassingly preceded by an obliterating 'post'.

To someone like myself who had grown up in the sunny optimism of the 50s and early 60s (when it was evident to one and all that technology, science, liberating 'modern' attitudes, design innovations, Hugh Hefner and endless economic betterment would take us forever down a yellow brick road of progress) this demise

of modernism came as an overwhelming, destabilizing shock.

But came it did. While the 60s had started with such great expectations (gleaming skyscrapers housing the likes of Don Draper and his *Mad Men*, *Playboy* and the pill kicking off a sexual revolution to match that brought by technology, the massive ranks of the Baby Boomers entering their teen years to a Rock 'N' Roll soundtrack) by the 'Summer of Love' in 1967 it was clear that things weren't working out quite how all those ads featuring happy families barbecuing American meat in the backyard of their suburban 'ranch' style home had envisioned it.

Nor did the Hippies' back-to-nature-let-it-all-hang-out-make-love-not-war alternative utopian vision work out as planned (as is so harrowingly depicted in Joan Didion's essay 'Slouching Towards Bethlehem' which gives a report from the front of San Francisco after the 'Summer of Love').[7] The 70s struggled with economic recession and emotional letdown until this non-specific but odiferous malaise found focus in those prescient pioneers of do-it-yourself, take-no-prisoners post-modernism, the Punks: 'No Future'.[8]

On the surface, the champers-slurping, cocaine-sniffing, de-regulated, loads-of-money, designer Yuppies of

[7] In Didion, Joan, *Slouching Towards Bethlehem*, London, 2001.

[8] See the chapter on 'Punk' in Polhemus, Ted, *Streetstyle*, London, 2010 and the 'No Future' chapter in Polhemus, Ted, *Style Surfing: what to wear in the 3rd millennium*, London, 1996.

the 80s seemed to have banished those 'No Future' blues of the dole queue 70s but, like the unlikely goings on at the Southfork ranch in *Dallas*, their 'lifestyle' utopia would eventually be revealed to be just a dream – a nasty shock awaiting the wide-eyed.

Also in the 80s, *Blade Runner* (1982) broke with more than a century of sci-fi futuristic optimism and shiny modernist aesthetics to propose not only a dystopian future (that had been done before) but one which was so fed up with modernism's love of tomorrow that everyone wore retro. Our hero (of sorts) Deckard dresses like a not totally square early 60s high school English Lit teacher. The tragic and beautiful Rachel is a replicant replicating the gorgeous glamour of 30s Hollywood. But it is the raccoon-eyed, bleach blonde, plastic fantastic replicant Pris who reminds us that *Blade Runner* is at heart a Punk film – aside from 'basic pleasure model' Pris, fleetingly, in one of those fantastic crowd scenes which in their stylistic diversity/chaos prefigure the Supermarket of Style which is to come, there are even two perfect Sid Vicious clones.

Or to put it another way, to describe *Blade Runner* as a 'Punk' film, is another way of saying that it is postmodern. Another great (but usually forgotten) 'Punk' film is Derek Jarman's *Jubilee* (1978) and within its own dystopian vision of a tomorrow clinging for safety and meaning to the past, the writing is literally on the wall: scrawled on a bombed out, crumbling concrete wall on

some dodgy London post-apocalypse street is the graffiti 'Post-Modern'. Cultural theorists and philosophers more knowledgeable than I may identify other defining characteristics of post-modernism but for my money the key elements are readily identifiable in *Jubilee*, *Blade Runner* and Punk: the yellow brick road of lineal progress falls off a cliff and in its place an infinity of parallel universes stack up on top of each other in a traffic jam of alternative realities – all of which on closer inspection turn out to be a little lacking in the reality department (but, hey, that's cool).

So when modernism bought the farm (or, perhaps, migrated South and East) so too did that ravenous desire and delight in The New which had for centuries fuelled the hot engine of fashion. And not only did the last few decades see a change in our attitude to change but this era since *Fashion & Anti-fashion* was first published has also seen a phenomenal rise in our hunger for individuality – most especially for a one-off, self-made, authentic individuality which (it is to be hoped) gives us meaning even within the endlessly replicating simulacrum of *The Matrix*; a *unique, bespoke, authentic* individuality which lets us stand apart from the mass of sad sack marketing target group, sheep-like replicants who have invaded our planet.

As well as causing us to refuse the dictated conformity which 'fashion victims' once put up with, even welcomed, our new cult of authentic individuality has also

made problematic membership in those very subcultures – including our po-mo heroes the Punks – which produced the streetstyle which first offered an alternative to the seemingly endless (not) succession of new 'New Looks' which the fashion system declared 'In'.

Post-fashion, post-subcultural, it's a you're-on-your-own-mate-free-for-all out there. Throughout the vast majority of human history your tribe set down very strict limits on your appearance. Then it was your traditional culture as subdivided into class, region, ethnic or other socio-cultural groupings. Surfing the wave of modernism which swept the West with the rise of social mobility and a middle class for whom change was often for the better, the fashion system demanded and got a level of conformity (and one which, uniquely, demanded quick-change compliance in time as well as space) which obliged even the likes of my mother, in the mid 60s, to get out a needle and thread and raise their hem lengths. And then suddenly, sometime in the 80s, not just a peculiar, alternative minority but your average Joe and Jane Consumer said the hell with it, refused to be dictated to, decided to sample & mix their own unique look and, in the process, began an era of unprecedented freedom in the ancient human endeavour of transforming appearance.

And just as such transformation of appearance served crucial functions throughout human history right back to marking the boundaries of 'our tribe' and visually sig-

nifying the defining features of 'our culture', so today, far from frivolous and insignificant, our endeavours to use creative consumption and sampled & mixed personal style to sketch out and advertise ourselves as unique, authentic individuals may just – maybe maybe maybe – permit us to Get Real. To find ourselves and, with a bit of luck, using our self-constructed style semiotics as a kind of radar, to find others who are on the same wavelength as ourselves.

For our distant ancestors right back to those proudly displaying their ochre body painting designs and shell necklaces in Blombos Cave in South Africa 70,000 years ago, style served to redefine and reinforce the social group and to articulate and visualize its beliefs and values. Now, in our age of individual freedom/atomized isolation, just maybe our self-generated personal styles can articulate networks of commonality as well as difference; articulating those values and beliefs which words can no longer signify and forging relationships and communities in the process.

Or, as I'm inclined to think in more cynical moments, post-modern style will just drown in an endless sea of (ever so carefully) distressed denim and expensive superbrand t-shirts. In my time, especially but not only in my Hippy days, everyone tried to avoid brand labelling of any sort – the ideal being to get your jeans or whatever from some little, one off shop where, if there was actually a visible label, it was for a company so obscure

that no one else had heard of them. And if your t-shirt had a message it was 'Make Love Not War', a marijuana leaf or the name of your fav band.

Strange then for an old Beat/Hippy/Punk/Goth/Perve like me to understand why so many people today will pay above the odds in order to let the world know that they are wearing a t-shirt which is 'Real Super-Dry' (or perhaps, fake 'Real Super Dry'?) or what, when I first saw it, I presumed was a law firm called 'Abercrombie & Fitch'. Personally I would expect to be paid a lot of money to walk around advertising Mr Abercrombie and Mr Fitch and their legal practice.

Even stranger to me is people who have made themselves walking adverts for 'Hollister'. For me, Hollister marks where we came in: 1947, motorcycle gangs take over Hollister, CA for the 4th of July weekend and this becomes *The Wild One* and then, 30 years later, that old devil Jean-Paul Gaultier is flogging 'Perfecto' style motorcycle jackets which cost as much as a Harley-Davidson. When I first saw people wearing 'Hollister' I wondered if yet another generation was discovering 'What you rebelling against?' 'Wha ya got?' So I started stopping people wearing 'Hollister' t-shirts and asking them if they know about the link with *The Wild One*. Acknowledging that my survey sample may have been a bit skewed towards attractive young women, I can report that 0% of those questioned on this issue had heard of *The Wild One* let alone the historical connec-

tion between Hollister, Bikers and the rise of subcultural anti-fashion in America.

The 'true' story of this sublimely post-modern tale is told by Wikipedia: it seems that, when Hollister Co. launched in 2000, it came complete with a 'pseudo history' based upon the fictional character of John M. Hollister who graduated from Yale University at the age of 21 and who, after a life of adventure sailing the South Pacific, founded a clothing company in Laguna Beach, CA. As you do. While ignoring the true story of how the name 'Hollister' signifies one of the great locations of style semiotics in the history of popular culture! The mind boggles.

Yet it must be admitted that John M. Hollister's story is a heck of a good tale – upper class pedigree, South Seas adventurer, laid-back Californian – and our post-modern age is desperately in need of a good narrative. And meaning. So let's not get our knickers in a twist over John M. Hollister: in an age when hedge fund managers ride their Harley-Davidson into the sunset, the original typed scroll of *On the Road* is itself on the road on tour and when everyone is a dude and everything awesome who is qualified to say what is authentic and what is not?

Wha ya got?

So it goes.

Ted Polhemus
Hastings, May 2011

Part IV

Selected Readings

Selected Readings from the 1978 edition

A full bibliography of our subject is impossible here. The reader is urged to investigate in particular the bibliographies contained in those sources preceded by an asterisk.

* Argyle, Michael, 'Clothes, physique and other aspects of appearance' in *Bodily Communication*, Methuen, London, 1975, pp. 323-44.

Barthes, Roland, *Système de la mode*, Seuil, Paris, 1967.

Bell, Quentin, *On Human Finery*, Hogarth Press, London, 1947.

Benthall, Jonathan, and Ted Polhemus (eds.), *The Body as a Medium of Expression*, Allen Lane, London, and E. P. Dutton, New York, 1975.

Brockman, Helen L., *The Theory of Fashion Design*, John Wiley & Sons, New York, 1967.

* Carter, Ernestine, *The Changing World of Fashion*, Weidenfeld and Nicolson, London, 1977.

Dunlap, Knight, 'The development and function of clothing' in *Journal of General Psychology*, vol. 1, 1928, pp. 64-78.

Faris, James C., *Nuba Personal Art*, Duckworth, London, 1972.

* Flügel, J. C., *The Psychology of Clothes*, Hogarth Press & The Institute of Psycho-analysis, London, 1930.

Gottwald, Laura and Janusz (eds.), *Frederick's of Hollywood 1947-73: 26 Years of Mail Order Seduction*, Strawberry Hill, New. York, 1973.

Hiler, Hilaire, *An Introduction to the Study of Costume: From Nudity to Raiment*, W. & G. Foyle, London, 1929.

* Howell, Georgina, *In Vogue: Six Decades of Fashion*, Allen Lane, London, 1975.

Kerouac, Jack, *On the Road*, Viking Press, New York, 1957.

– *The Subterraneans*, Grove Press, New York, 1958.

* König, René, *The Restless Image: A Sociology of Fashion*, George Allen & Unwin, London, 1973.

* Laver, James, *A Concise History of Costume*, Thames and Hudson, London, 1969.

*— *Modesty in Dress: An Inquiry into the Fundamentals of Fashion*, William Heinemann, London, 1969.

MacInnes, Colin, *Absolute Beginners*, MacGinnon & Kee, London, 1959.

Newton, Stella Mary, Health, *Art and Reason: Dress*

Reformers of the Nineteenth Century, John Murray, London, 1974.

Perutz, Kathrin, *Beyond the Looking Glass: Life in the Beauty Culture*, Penguin, Harmondsworth, 1972.

* Polhemus, Ted (ed.), *Social Aspects of the Human Body: A Reader of Key Texts*, Penguin, Harmondsworth, and Pantheon, New York (as *The Body Reader*), 1978; see chapters 5, 6 and 8.

Richardson, Jane, and A. L. Kroeber, 'Three centuries of women's dress fashions; A quantitative analysis' in *Anthropological Records*, vol. 5, no. 2, University of California Press, Berkeley, 1940.

* Roach, Mary Ellen & Joanne Bubolz Eicher (eds.), *Dress, Adornment, and the Social Order*, John Wiley & Sons, New York, 1965.

Rudofsky, Bernard, *The Unfashionable Human Body*, Hart-Davis, London, 1972.

Saint-Laurent, Cecil, *The History of Ladies' Underwear*, Michael Joseph, London, 1968.

* Scutt, Ronald, and Christopher Gotch, *Skin Deep: The Mystery of Tattooing*, Peter Davies, London, 1974.

* Squire, Geoffrey, *Dress Art and Society: 1560-1970*, Studio Vista, London, 1974.

Strathern, Andrew and Marilyn, *Self-Decoration in Mount Hagen*, Duckworth, London, 1971.

Turner, Terence S., 'Tchikrin: A central Brazilian tribe and its symbolic language of bodily adornment' in *Natural History*, vol. 78, October 1969, pp. 50-9, 70.

Veblen, Thorstein, *The Theory of the Leisure Class*, George Allen & Unwin, London, 1970.

Wolfe, Tom, 'Funky Chic', in *Mauve Gloves & Madmen, Clutter & Vine*, Farrar, Strauss & Giroux, New York, 1976.

– 'Radical chic' in *Radical Chic and Mau-mauing the Flak Catchers*, Farrar, Strauss & Giroux, New York, 1970.

– *The Electric Kool-Aid Acid Test*, Farrar, Strauss & Giroux, New York, 1968.

– *The Pump House Gang*, Farrar, Strauss & Giroux, New York, 1968.

Additional selected reading for the 2011 edition

Here are some works which appeared after the original publication of Fashion & Anti-fashion *(or which I was unaware of at the time) but which may be relevant to its subject matter.*

Camphausen, Rufus C., *Return Of The Tribal: A Celebration of Body Adornment*, Rochester, Vermont, 1997.

Caplan, Jane (ed.), *Written on the Body: The Tattoo in European and American History*, London, 2000.

Chambers, Iain, *Border Dialogues: Journeys in Post-modernity*, London, 1990.

– *Urban Rhythms: Pop Music and Popular Culture*, London, 1985.

Chenoune, Farid, *A History of Men's Fashion*, Paris, 1993.

Clarke, Pauline, *The Eye of the Needle*, Nuneaton,

Warkwickshire, England, 1994.

Cohn, Nik, 'Today There Are No Gentlemen', in *Ball the Wall*, London, 1989.

Cosgrove, Stuart, 'The Zoot Suit and Style Warfare', in Angela McRobbie, ed., *Zoot Suits and Second-hand Dresses: An Anthology of Fashion and Music*, London, 1989.

DeMello, Margo, *Bodies of Inscription: A Cultural History of the Modern Tattoo Community*, Durham, USA, 2000.

Didion, Joan, *Slouching Towards Bethlehem*, London, 2001.

Farren, Mick, *The Black Leather Jacket*, London, 1985.

Goldberg, Joe, 'The Birth of Cool', in Gene Sculatti (ed.), *A Catalog of Cool*, New York, 1982.

Goody, Tiffany, *Tokyo Street Style: Fashion In Harajuku*, London, 2008.

Hebdige, Dick, *Cut 'N' Mix: Culture, Identity and Caribbean Music*, London, 1987.

– *Subculture: The Meaning of Style*, London, 1979.

Jameson, Frederic, *Postmodernism or the Cultural Logic of Late Capitalism*, London, 1991.

Keet, Philomena, *The Tokyo Look Book: Stylish To Spectacular, Goth To Gyaru, Sidewalk To Catwalk*, Tokyo, 2007.

Lautman, Victoria, *The New Tattoo*, New York, 1994.

Levy, Shawn, *Ready, Steady, GO!: The Smashing*

Rise and Giddy Fall of Swinging London, New York, 2002.

Lobenthal, Joel, *Radical Rags: Fashions of the Sixties*, New York, 1990.

Macias, Patrick & Izumi Evers, *Japanese Schoolgirl Inferno: Tokyo Teen Fashion Subculture Handbook*, San Francisco, 2007.

Melly, George, *Revolt into Style*, Oxford, 1989.

Mercury, Maureen, *Pagan Fleshworks: The Alchemy of Body Modification*, Rochester, Vermont, 2000.

Musafar, Fakir, *Body Play: The Book, Volume 1*, Menlo Park, CA, 1995.

Polhemus, Ted, *Bodystyles*, Luton, England, 1988.

– *Diesel: World Wide Wear*, London, 1998.

– *Hot Bodies Cool Styles: New Techniques in Self-Adornment*, London, 2004.

– *Streetstyle*, London, 1994 (Thames & Hudson); new edition, London, 2010 (PYMCA).

– *Style Surfing: what to wear in the 3rd millennium*, London, 1996.

Polhemus, Ted & Pacoda, Pierfrancesco, *La Rivolta Dello Stile*, Padova, Italy, 2008.

Polhemus, Ted, and Procter, Lynn, *Pop Styles*, London, 1984.

PYMCA (with Ted Polhemus and others), *Unordinary People*, London, 2009.

Redhead, Steve, *The End-of-the-Century Party*, Manchester, 1990.

Rubin, Arnold (ed.), *Marks of Civilization: Artistic Transformations of the Human Body*, Los Angeles, 1988.

Savage, Jon, *England's Dreaming: Sex Pistols and Punk Rock*, London, 1991.

– *Teenage: the creation of youth 1875-1945*, London, 2007.

Thorne, Tony, *Fads, Fashions & Cults: From Acid House to Zoot Suit*, London, 1993.

Tulloch, Carol, 'Rebel without a Pause: Black Street-style & Black Designers', in Julia Ash and Elizabeth Wilson, (eds.), *Chic Thrills*, London, 1992.

Vale, V and Juno, Andrea (eds.), *RE Search: Modern Primitives: An Investigation of Contemporary Adornment & Ritual*, San Francisco, 1989.

Wakefield, Neville, *Postmodernism: The Twilight of the Real*, London, 1990.

Wood, David (ed.), *Torture Garden: Body Probe: Mutating Physical Boundaries*, London, 1999.

York, Peter, *Modern Times*, London, 1984.

www.tedpolhemus.com